Jim Morin's World

40 Years Of Social Commentary From A Pulitzer Prize Winner Cartoonist

For permission requests, please contact the publisher at:
Mango Publishing Group
2850 Douglas Road, 3rd Floor
Coral Gables, FL 33134 USA
info@mango.bz

For special orders, quantity sales, course adoptions and corporate sales, please email the publisher at sales@mango.bz. For trade and wholesale sales, please contact Ingram Publisher Services at customer.service@ingramcontent.com or +1.800.509.4887.

Library of Congress Cataloging
Names: Morin, Jim
Title: Jim Morin's World: 40 Years Of Social Commentary From A Pulitzer Prize Winner Cartoonist / by Jim Morin
Library of Congress Control Number: 2016920253
ISBN 9781633535077 (paperback), ISBN 9781633535060 (eBook)
BISAC Category Code: HUM001000 HUMOR / Form / Comic Strips & Cartoons

Front Cover Image: Jim Morin/Miami Herald
Back Cover Image: Jim Morin/Miami Herald

Jim Morin's World: 40 Years Of Social Commentary From A Pulitzer Prize Winner Cartoonist
ISBN: 9781633535077

Printed in the United States of America

"We're lucky to have one of the very best, waiting with pen in hand to carve up the phonies, blowhards, crooks and hypocrites who make headlines. They might not want to end up in a Jim Morin cartoon, but they will."

– *Carl Hiaasen*

"Jim Morin has all the attributes of a first-rate cartoonist. He has a clear idea how he feels about issues and he wants you to know about it. He then expresses himself clearly and concisely in a manner that is both exciting and explorative."

– *Pat Oliphant*

"Jim Morin is one of the great under-appreciated cartoonists of the last quarter century"

– *The Comics Reporter*

FOREWORD

The best editorial cartoonists are writers at heart.

Not frustrated writers – serious, gifted, and prolific writers. They're able to express with a few lines, or sometimes just a single word, what a columnist struggles to say in reams. And some of their most powerful cartoons have no words at all. The very act of political drawing is a way of writing, each flick of the pen as crucial as an adjective in a sentence. Yet while a columnist might get away with rambling, or the occasional clunky phrase, the cartoonist is a prisoner of precision.

There's no place in that little panel for dead air. Jim Morin has been publishing cartoons for 40 years at the Miami Herald, and those of us who merely write for the newspaper are still astounded daily by how deft and fearless he is. Plenty of cartoonists can do a number on Donald Trump's hair, Barack Obama's ears, or Vladimir Putin's glare. Caricature is the easier part of the job. The harder part is composing something timely and important. All you've got to do is come up with a really clever idea, every day. Then you've got to sit down and draw it perfectly – on deadline. No pressure there, right?

Good editorial cartoons, like good columns, always rankle somebody. That isn't a sworn mission; it's just the natural result of expressing an opinion that not everyone will embrace.But, again, columnists have it easier because readers who disagree with our viewpoints can easily dodge our words. All they've got to do is stop reading, and look elsewhere in the newspaper for something more palatable to read.

An editorial cartoon, however, cannot be avoided or even skimmed. It's right there, in your face. The moment you open the Herald to the Opinion pages, or to the homepage of the website, you see Jim Morin's latest creation. The visual connection is instant, and so is the jolt. This impressive, highly entertaining collection of Jim's work arrives at a time when many Americans fear the country is hopelessly divided, and on the brink of historic upheaval.

Yet these cartoons remind us with humor, heartache and humanity that we've endured decades of tumult – the Iran-contra scandal, Mariel boatlift, Bill Clinton's impeachment, the hanging chads of Bush v. Gore, the 9/11 attacks, the occupation of Iraq, the financial crash of 2008... and that's the short list. Jim would be the first to admit that working in crazy, scandal-plagued South Florida gives him a geographic edge over other editorial cartoonists. No other place is such a target-rich environment for satirists.

We're lucky to have one of the very best, waiting with pen in hand to carve up the phonies, blowhards, crooks and hypocrites who make headlines. They might not want to end up in a Jim Morin cartoon, but they will.

We're all counting on it.

Carl Hiaasen

THE ARTIST AND HIS PHILOSOPHY

Exerpt from convocation speech to graduates at Jim Morin's alma mater, Syracuse University School of Visual and Performing Arts.

In my junior year, I had an instructor teaching me the finer points of how to illustrate washing machines, refrigerators, and microwave ovens. He had begun his career at General Electric, painting these appliances for the company's advertisements. The class was told that he had accomplished what we all aspired to -- making the jump from "commercial" to "fine" art, that his harbor scenes won awards around the country.

We didn't have the heart to tell him that his boats looked like refrigerators, his boathouses like washing machines, and his sea gulls like microwave ovens.

Toward the end of the semester, he took the class on a field trip to General Electric. We walked into this enormous room divided into little cubicles, each with an artist painting refrigerators, washing machines, and microwave ovens.

A friend and I lagged and met one of these draftsmen, who offered a few words of advice: "Whatever you do, don't get married and have children until you have found some measure of fulfillment in your work." He described his own situation as: "Stuck."

Even today I think about that man. He has had a profound influence on my life, and I fervently hope that he escaped. A few months after the field trip, I attended a seminar on the music industry featuring Frank Zappa. During the question-and-answer session, a student told Zappa that he hadn't made a decent album since 1967's "We're Only in It for the Money". Zappa leaned toward the microphone and, his voice dripping with sarcasm, responded: "There's nothing that pleases me more than making you happy with my music!" We roared in laughter. Here was a man who refused to compromise and was prepared to defend his work.

Those experiences steered me toward doing just what I wanted and instilled a burning desire to do it with honesty and caring.

My real education has come at odd moments when least expected. It continues to do so. As art students, we lived inside a bubble being taught the fundamentals of our craft, but with little contact with the "outside world." The most highly regarded students were those who could render a picture with realistic accuracy. But that work lacked meaning and passion and purpose.

It may be impossible for art schools to teach meaning, passion, and purpose. But requiring all art students to read a newspaper, or perform some sort of community service, or in some other way open up to life outside the classroom may help point us in the direction that sets off that spark, that inspiration that becomes our bedrock.

That is when -- from each and every one of you -- the special interpretation of our existence that is particular to you and to you only will emerge in your art.

It's not easy. Asserting one's individuality through work is harder than ever. The tendency to copy already-established successful artists as a means toward quick and easy success is everywhere. My own field is overflowing with inferior copies of the most prominent artists. Even more disturbing to me is the fact that some of these imitators are extremely successful, while at the same time the work of truly courageous and original editorial cartoonists goes unheralded.

Look to one of my personal artistic heroes, Lucian Freud, a painter who, no matter what fashion was taking over the art world, painted the figure. He had a vision formed by his love of the work of others who had come before him, as well as by his own life experiences, by his feelings toward humanity, by his feeling of inadequacy, by his longing that his painting not resemble the subject but be the subject.

He was aware of the Abstract Expressionism, Pop Art, Minimalism, and other prevailing styles of the times, but he continued to follow his vision. And eventually, instead of following the public taste, the public came to him.

Each and every one of you here, whether you are a musician, actor or actress, dancer, painter or illustrator, has that individual spark inside of you. Each and every one of you has a point of view unlike any other. When you take that point of view and perfect its expression within your art, you give the rest of us a very rare gift.

Ignore the marketplace, forget what you think we want to see or hear. Go after your innermost feelings. Our society has an unquenchable thirst for honesty and integrity. We want to hear what you have to say.

Say it.

May 18, 1998

Jim Morin

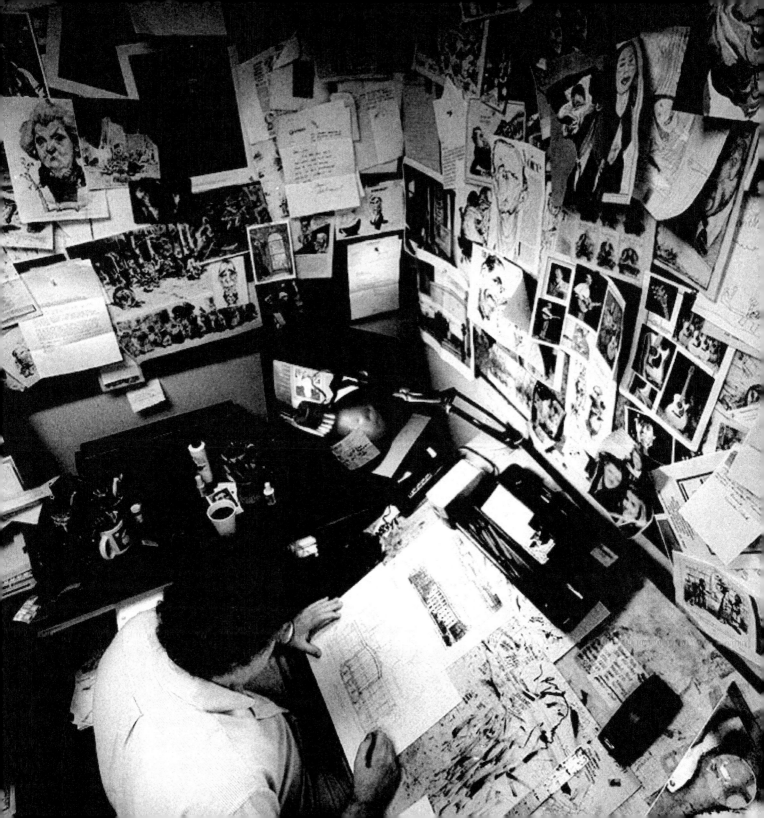

MAKING LIGHT OF THE DEADLY SERIOUS

Jim Morin's office at The Herald is a windowless cubbyhole decorated in perpetual disarray. At least it always looks mildly chaotic when you walk in and find him hunched over the drawing board, CNN blasting away on a small TV screen to his left and a neglected computer on his right. The office's cork-covered walls bear other people's art work - offering the eye everything from the sublime (turn-of-the-century artist T.S. Sullivant's animal caricatures - a Morin favorite) to the ridiculous (a reader's letter that begins, "Morin, this is sick stuff . . .").

There is also a poster from the Panthers' 1996-'97 championship season (he's a Panthers fan, a weekend hockey warrior and has a career-shortening knee injury to prove it); numerous photos of Morin's two children, Elizabeth, who is "almost 12," and Spencer, 11; a classic 1960s photo of the Beatles (he's a diehard fan); various caricatures of the famous and infamous by himself and other artists; a brochure for handmade acoustic guitars (he's an avid guitar player), and other bits and pieces of this funny, kind of shy, dynamic man's working days and personal passions.

Fairly prominent among the flotsam on the cork wall are two letters with New York Post on the letterhead signed by Pete Hamill, both in praise of particular Morin cartoons that struck the veteran newspaper columnist's funny bone.

Morin scores many direct hits on readers' funny bones - and he ticks off a lot of readers, too. It's supposed to work that way in the editorial-cartoon business.

"When you put your opinion out there 250 times a year, you're going to make people mad at some point," is Morin's reaction to the calls and letters and e-mails that take him to task. And when it comes to his critics as well as his fans, "There are two kinds of liars," Morin tells me, "those who say they love everything you do, and those who say they hate everything you do."

Jim Morin at work in his office at the Herald, September 10, 1999 (Chuck Fadely/Miami Herald)

9

In between are, "The ones who give the honest answer by saying, 'I don't always - or even very often - agree with you, but I respect your work.' "Or in other words, "That cartoon today sucked, but others you've done don't."

Don't call Morin today, though, to give him your opinion because he's not in. The Herald's editorial cartoonist, who won the Pulitzer Prize in 1996, is in Landau, Germany, this week being honored as the latest recipient of the Thomas Nast Prize. He is only the seventh American cartoonist to win the award, given periodically by the Thomas Nast Foundation.

Nast was born in Laudau in southwest Germany in 1840. He lived until 1902 and is the only newspaper political cartoonist whose name, a century after his work was published, still is universally known.

His work day begins around 9:30 a.m., when, sketch pad and pen in hand, he walks into Herald Editorial Pages Editor Tom Fiedler's office, where the Editorial Board holds its daily morning conference. Here's how Morin describes his day:

"I go to the Editorial Board meeting. Then I go to sleep. Then I wake up . . ." This is followed by his very best Jim Morin laugh, a roaring ha-ha-ha-ha that ends in a more-serious "No, really. Just listening to the debate [on issues discussed each day] gives me energy, which I bring back to my office and then go on from there."

An artist can represent great frustration to a writer. With a few strokes of his pen, Jim Morin often expresses what a good editorial might struggle to do in 450 words. What's more, he's funny - a gift, nurtured by hard work. After graduating from Syracuse College of Visual and Performing Arts, he sent "300 to 400" letters of inquiry to newspapers with circulations of 60,000 or more. Eventually, The Beaumont (Texas) Enterprise and Journal hired him. Although a long way from his native Massachusetts, "I was thrilled just to get in the business," he says.

"That paper put up with a lot of growing pains. You wouldn't recognize my work from that time. My stuff was very dark. I was into German expressionism, which didn't go over all that well in Texas . . ."

He moved on to The Richmond (Va.) Times Dispatch, whose rival, the Richmond News Leader, boasted of Jeff MacNally, now with the Chicago Tribune. "My editors wanted me to be like Jeff, who is a very, very classy guy. So I went out of my way not to be like him. Nobody wants to imitate another cartoonist."

More and more, the unique, round-figured Morin style developed, supplanting the German impressionism. Morin credits another well-known political cartoonist, Pat Oliphant, for teaching him "how to use humor. A cartoonist learns to use humor to help make the point, but not get in the way of it."

He came to The Herald in 1978, having been noticed by former Herald Editor Jim Hampton, who retired at the end of last year.

Once the daily editorial conference is finished, Morin cruises back to his office, turns on CNN (before the all-news network began he listened to the Beatles, Leo Kotke and the Moody Blues while he drew) and hunkers down to draw with black, felt-tipped markers and a scratch pad.

Sometimes, he'll come up with five or six different, roughly sketched cartoon concepts on the same subject. He'll take them to Fiedler to get a second opinion, as he did to Jim Hampton for 20 years.

"Usually, if there's one I know is the best, in my view, that'll be the same one that'll be picked out as the best of the lot. That's the one people will usually see in the paper the next day."

Next, he draws the actual cartoon, refining and shaping it into his easily recognized style. Off to the camera room it goes, usually by midafternoon. Morin's cartoons are also syndicated by King Features and appear in as many as 40 newspapers.

Morin also does caricatures (a current favorite is that of Republican presidential-candidate and Texas Governor George W. Bush). And he has resumed doing the Magic City cartoon panels on Sundays for the Otherviews Etc. page whenever local events offer appropriate inspiration (not too tough in this locale).

Of Magic City, he says, "I created it because it's hard to come up with a single panel (cartoon) on local issues sometimes. Here, things are so convoluted, that we don't have simple problems, or simple solutions." That's not funny, but it sure is the truth, something Morin is awfully good at depicting with those seemingly effortless strokes of his pen five days a week.

September 21, 1999
Kathleen Krog

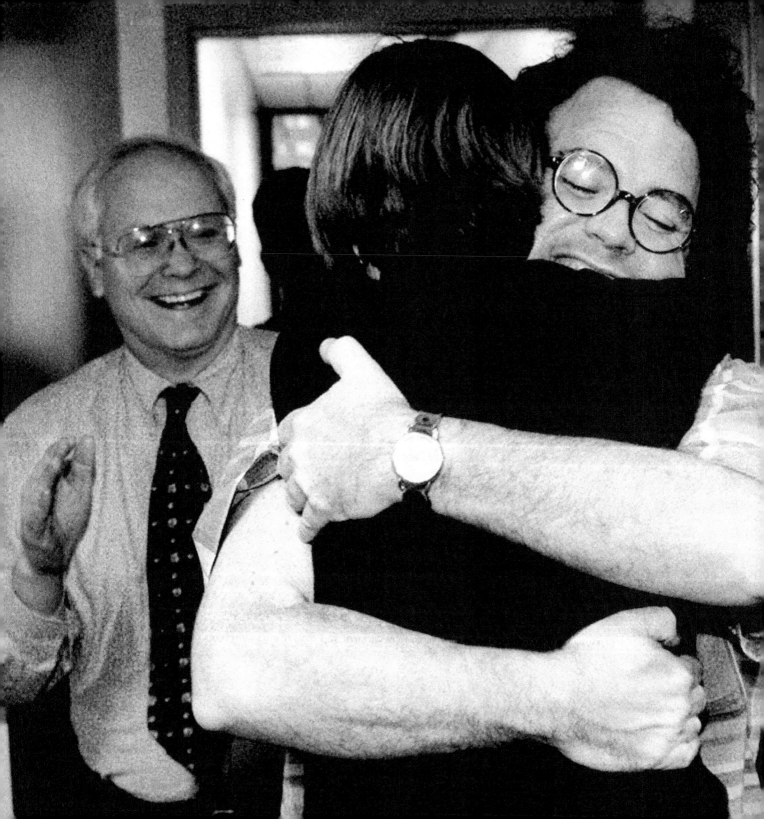

1996 PULITZER PRIZE

Herald editorial cartoonist Jim Morin, long considered one of the nation's sharpest, put the cap on his reputation Tuesday by winning the Pulitzer Prize.

So shocked was the unassuming, bespectacled satirist -- though perhaps he should not have been -- that if forced to draw his reaction, it would have been thus: "With my jaw dropping to the floor," he said.

His colleagues were not nearly so surprised. His boss, Editor Jim Hampton, had long expected that Morin would one day win journalism's highest prize. Through sources, he learned of the award Friday but succeeded in keeping it quiet until the official announcement Tuesday afternoon.

"It was the hardest secret I've ever kept," Hampton said. "I felt he's been overdue for this. Jim's style is original in a field in which many people copy the leaders. He doesn't copy anyone. He's bold, he's fresh, he's constantly inventive."

As the news bulletin flashed across a computer terminal, a shout of joy erupted from reporters and editors who just seconds before had gathered in The Herald's newsroom. Before they could toast Morin with champagne, he had to be dragged out of the office where he spends his days closeted at a drawing board.

"I just don't believe it," he said. "It's been 20 years of really hard work, and this is a culmination of sorts. It's a pat on the back, saying, 'Nice job.' And you wake up the next day and go back to work."

Miami Herald Editorial Cartoonist Jim Morin gets a hug from reporter Sydney Freedberg (back to camera) as he finds out he has won the 1996 Pulitzer Prize while Herald Publisher Dave Lawrence applauds at left, April 9, 1996. (Chuck Fadely/Miami Herald)

Noting that editorial cartoonists are something of an endangered species -- several have been recently laid off by cost-cutting newspapers -- Morin gave credit to Hampton and Herald Publisher David Lawrence.

"The tendency in editorial cartooning these days is that they're used as comic relief," he told his colleagues. "I feel fortunate to work for these guys. Not only do they not like that kind of cartoon, they actually reject my cartoons if they're too soft."

He also thanked the newsroom staff for keeping him well informed. "If it weren't for you doing your job well, I wouldn't have a chance," he said. Morin, 43, had been a Pulitzer finalist in 1990. An oil painter as well as a student of politics, he is admired by other cartoonists for his fine pen as much as for his often-biting commentary.

His trademark chiseled, stumpy figures have paraded across the Herald's editorial pages five days a week since late 1978. His editorial cartoons are syndicated through King Features and run regularly in 26 newspapers. Recently, he also began drawing a weekly strip called Magic City for Tropic, The Herald's Sunday magazine.

Morin is a nonpartisan lampooner, succinctly targeting the hypocrisy of politicians of all ideological stripes or the absurdities of modern life. To Morin, raising hackles is a necessary part of the cartoonist's job. It doesn't bother him if someone doesn't think a particular cartoon is funny.

"I want to express an opinion," he said, "what you find outrageous or amusing about the world we live in. Political cartoons don't have to be funny to be good." Morin was born and raised in a propitious place for a political cartoonist -- Washington, D.C., whose follies he would later puncture with such relish.

"Growing up in the '60s and approaching draft age for the Vietnam War, you were interested in current affairs -- intensely," he said. "I was also interested in animated cartoons. "It was actually my mother, who was a fine artist, who suggested I try political cartooning as a great way to make a living and combine those two interests."

He began his cartooning career at the Daily Orange in Syracuse University, where he majored in illustration and minored in painting. It took him a year to find a job, at the Beaumont (Texas) Enterprise and Journal. Let go in an economy move, he worked the next 18 months at the Richmond Times- Dispatch in Virginia.

After several failed attempts, he was hired in 1978 by The Herald, which had no editorial cartoonist at the time. He said he could not have landed in a place with richer material. "What a great place to draw about," he marveled. "It was a huge challenge -- the days of riots, of cocaine cowboys, of Joe Carollo and Maurice Ferre."

Of course, Carollo and Ferre are now back, and Morin isn't about to go anywhere else. "You really grow to love this place. As long as the paper will let me mouth off, it's my pleasure."

Wednesday, April 10, 1996
Andres Viglucci

WITH MALACE TOWARD ALL

ART OF CARTOONING THE CANDIDATES: WITH MALACE TOWARD ALL

The consensus among cartoonists is that caricature is created solely through exaggerating physical features relative to the appearance of the subject. I've never agreed with this slide-rule approach. Caricature is a visual commentary on what kind of man or woman that politician is. Just as important as physical appearance is how they sound, what they say, what they stand for, their accomplishments or lack thereof, and so on. Caricatures are not mere likenesses; they are psychological portraits that stem from something deeper than human anatomy.

Cartoonists are always asked during an election how they like drawing candidates. The better time to ask this question is four years after the election. Caricatures evolve over time the same way an administration does. My George W. Bush drawings when he was running in 1999 are a far cry from what they are now. With each scandal, screw-up, flip-flop and outrage, he grew angrier, meaner and very much smaller. When Gerald Ford first took over the presidency, cartoonists were whining about his "dull" physical appearance. Yet when Ford tripped down the stairs of Air Force One, at the same time proposing to fight against inflation with WIN buttons, those caricatures of him started to gel really fast. Richard Nixon? Say no more! He's the perfect storm of personality, policy and appearance.

Hillary was (and will be) a great joy to draw. She has always struck me as someone playing a leader as opposed to actually being one. Her speeches sound as if she is trying to be someone else -- JFK, Roosevelt, Reagan, Bill or Barack. The phoniness is inescapable. Cartoonists focus on her rabbit-like front teeth, but for me Hillary's ruthless ambition can be seen in her piercing eyes. The only downside: her ever-changing hairstyle drives caricaturists nuts.

McCain is fun to draw because we know him already to some extent: the "maverick," independent thinker, unpredictability, volcanic temper, goofiness, bad jokes. After having drawn him many times, I once put a very long distance between the bottom of his nose and his mouth. For some reason, it worked, it visually said "John McCain." That exaggeration makes no sense when you measure his facial features, but it feels appropriate when you hear the sound of his voice.

Barack Obama is problematic because we don't know him yet and therefore have little of substance to go on. Race, by the way, has nothing to do with it. Caricature is colorblind, and everyone is treated with equal malice. The more Obama resorts to platitudes, flip-flops, verbal bumbles and tumbles, the more his caricature will evolve and stretch. This current lack of familiarity is one reason why drawings of Obama are now fairly literal with little exaggeration. If he is elected, that will change, and it will be change you can believe in.

September 7, 2008
Jim Morin

17

1980s

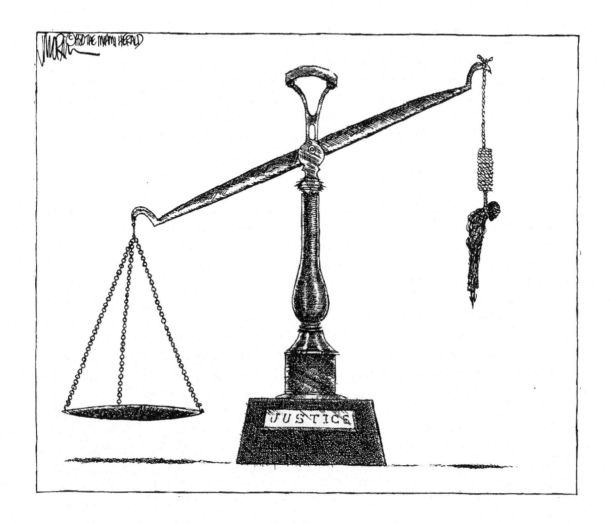

Race riots broke out on May 18, 1980 in Overtown and Liberty City, Florida following the acquittal of four Miami-Dade police officers involved in the death of Arthur McDuffie. McDuffie, a former Marine and salesman, died from the injuries he sustained at the hands of the police officers after a high-speed chase.

5/20/1980

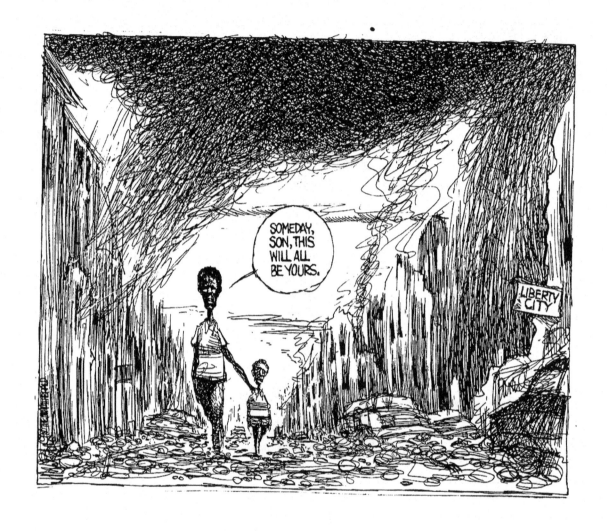

5/24/1980

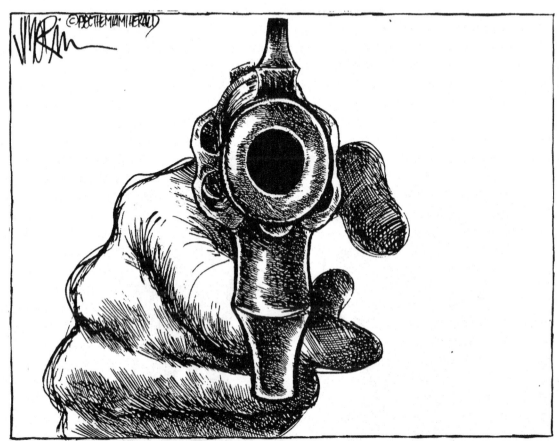

MIAMI. SEE IT LIKE A NATIVE.

8/27/1980

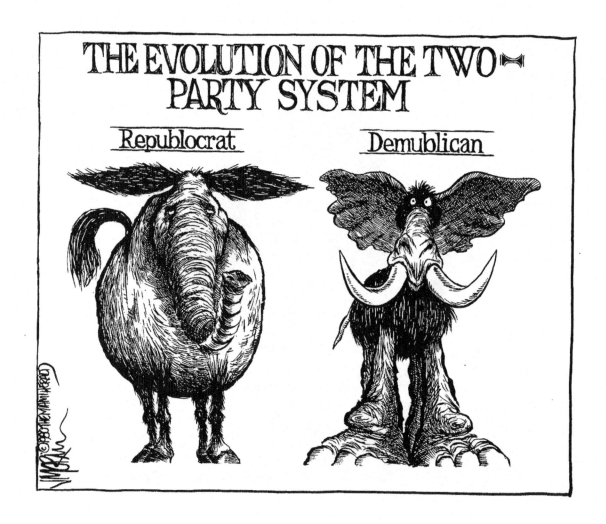

9/11/1980

OUR KROME AVE. 'TIS OF THEE.

In the 1980s, the Krome Avenue Detention Camp near the Everglades was used to house Haitian refugees. The Camp became the focal point for the Haitian struggle to be accepted as something other than economic refugees — a label that for the past 60 years had resulted in the automatic return of refugees to their homeland, political asylum denied.

1/8/1982

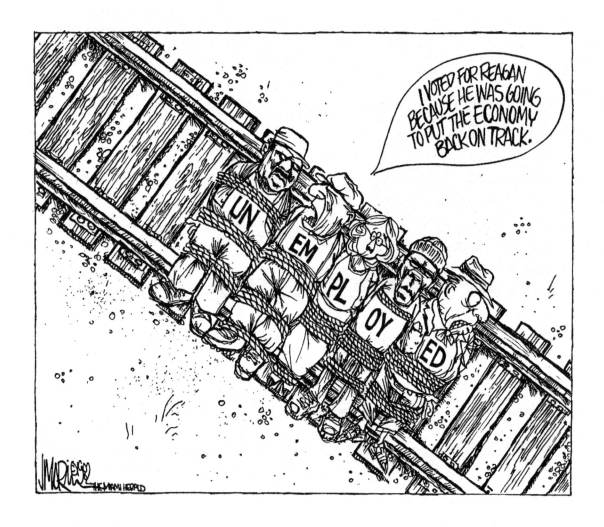

The four pillars of reagonomics were to reduce the growth of government spending, decrease the federal income and capital gains taxes, decrease government regulation, and reduce inflation.

1/12/1982

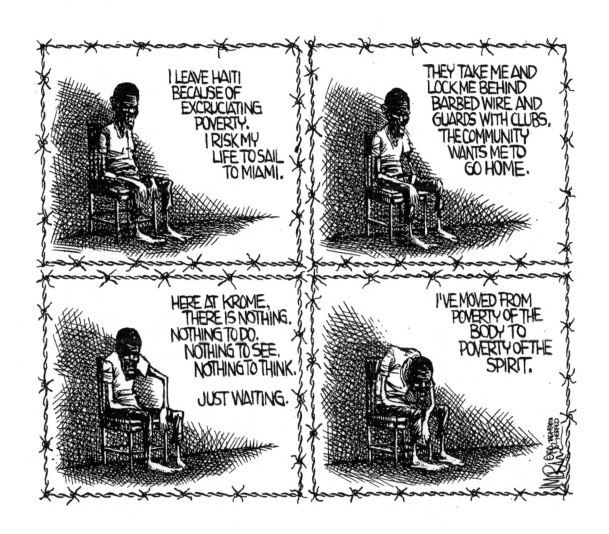

6/1/1982

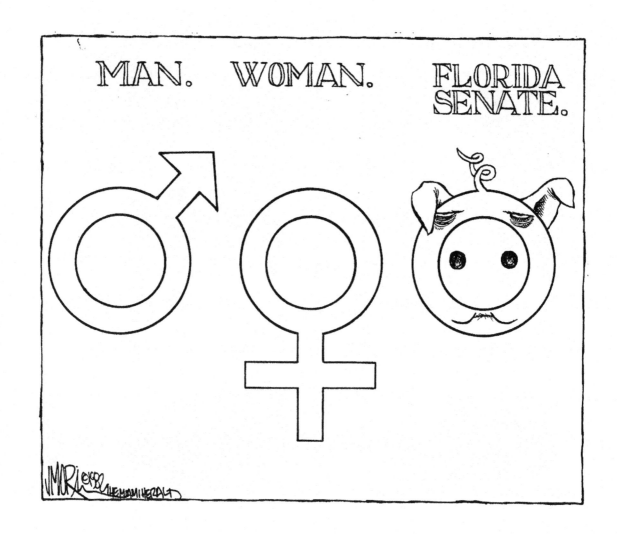

6/24/1982

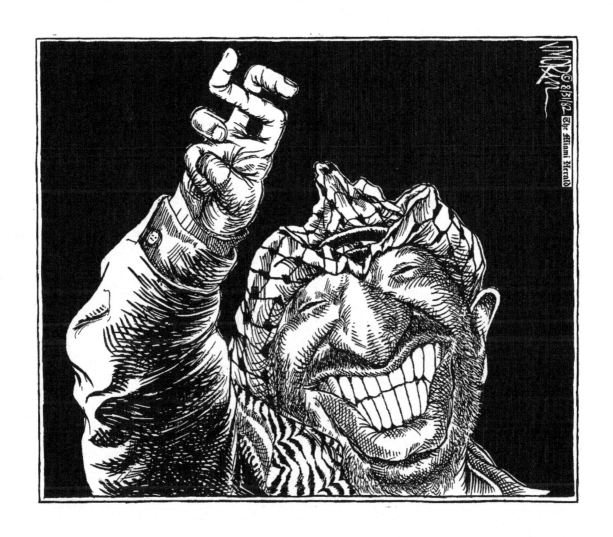

Arafat's PLO continues to implement Amin Al-Husseini's vision of "Murder the Jews."

8/31/1982

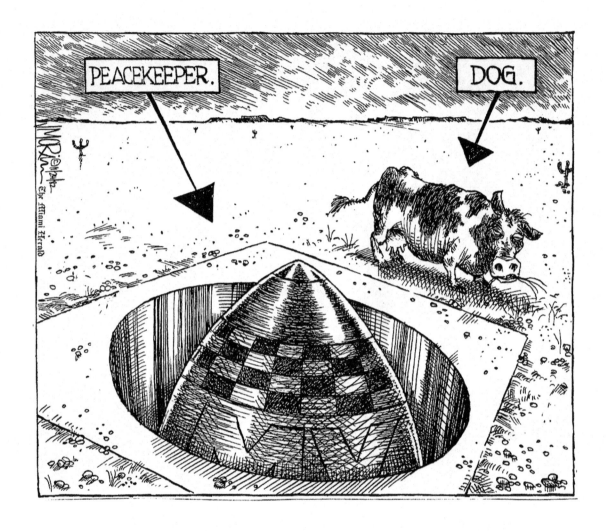

The "Peacekeeper" Intercontinental Ballistic Missile was deployed in silos in Wyoming and was operational from 1987–2005.

11/24/1982

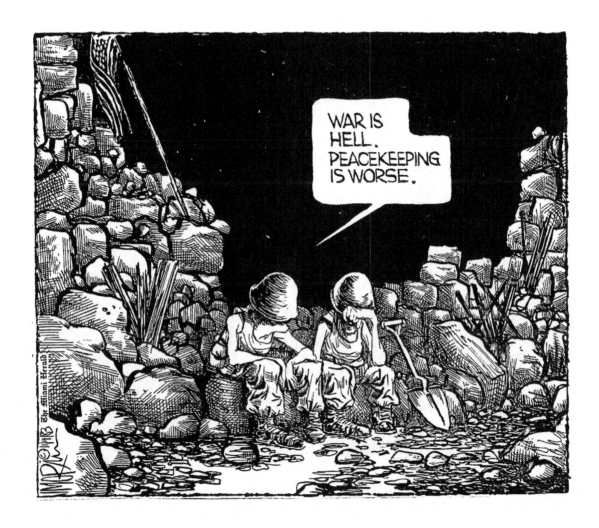

On October 23, 1983, 241 U.S. Marines and other U.S. military victims were killed by an Islamic Jihad terrorist truck bomb while sleeping in their barracks in Beruit. They were members of the Multinational Force in Lebanon (MNF) "peacekeepers".

11/4/1983

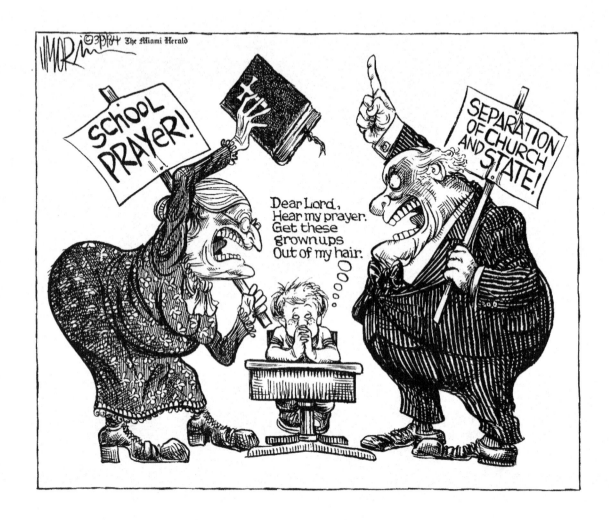

3/9/1984

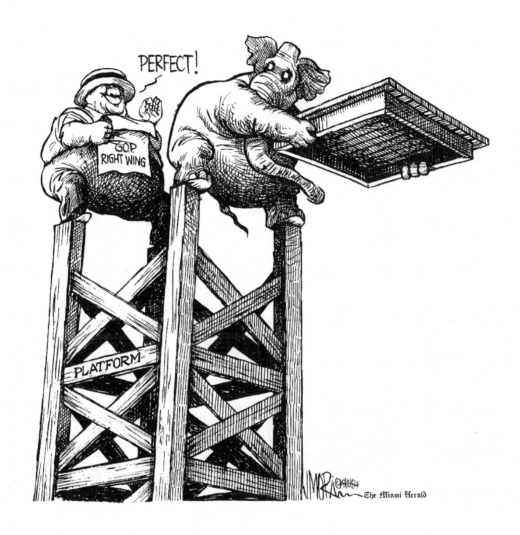

8/16/1984

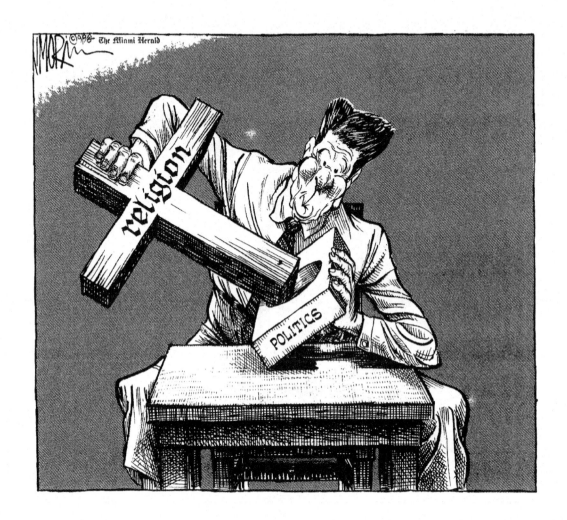

9/9/1984

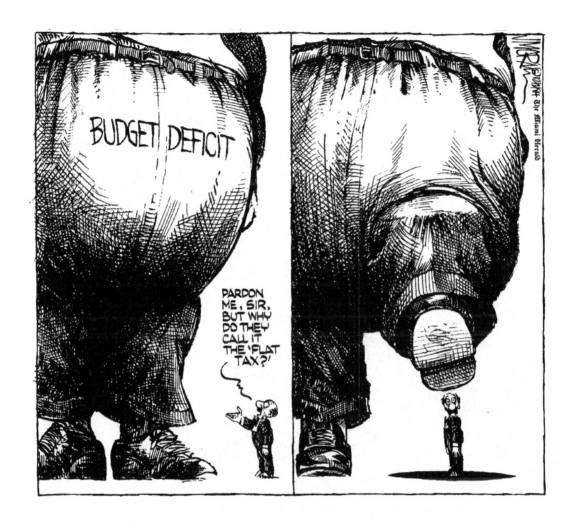

Flat tax is a system that applies the same tax rate to every taxpayer regardless of income bracket.

12/2/1984

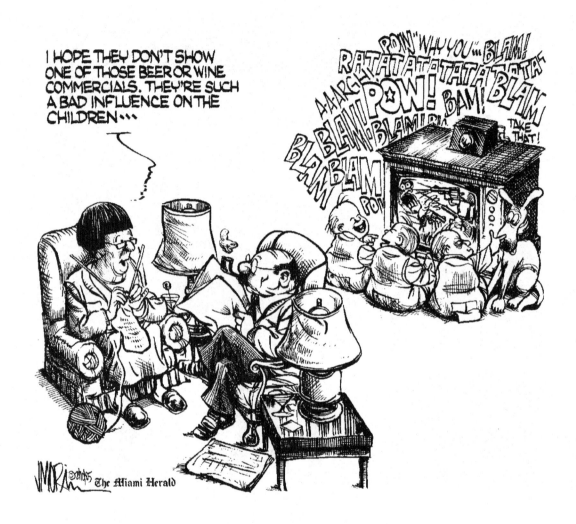

2/10/1985

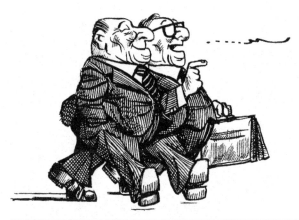

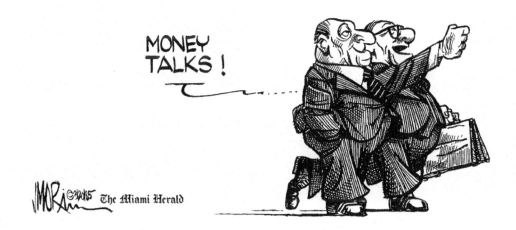

3/20/1985

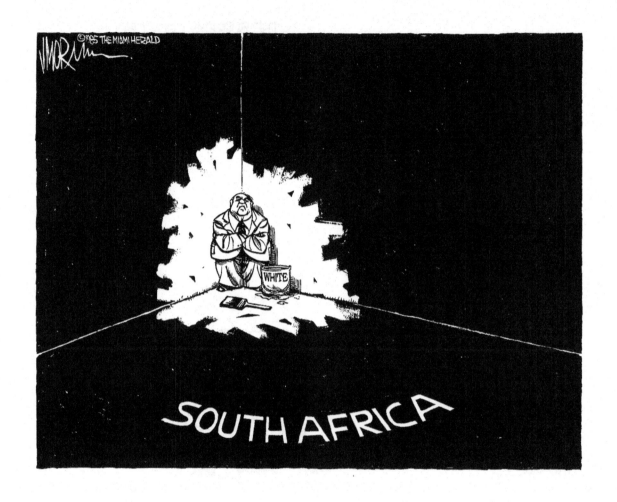

The government of South Africa maintained and enforced a system of racial segregation and discrimination, or Apartheid, between 1948 and 1991, when it was abolished. P. W. Botha served as the leader of South Africa from 1978 to 1989.

4/15/1985

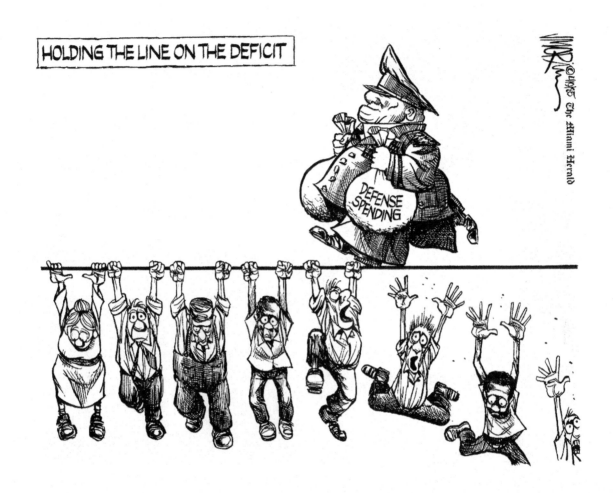

4/19/1985

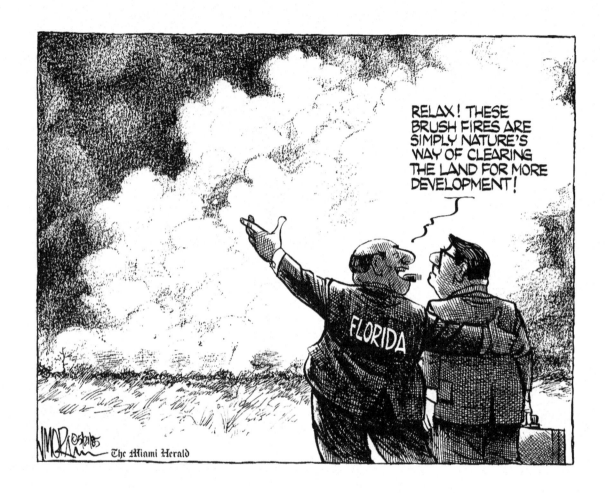

5/21/1985

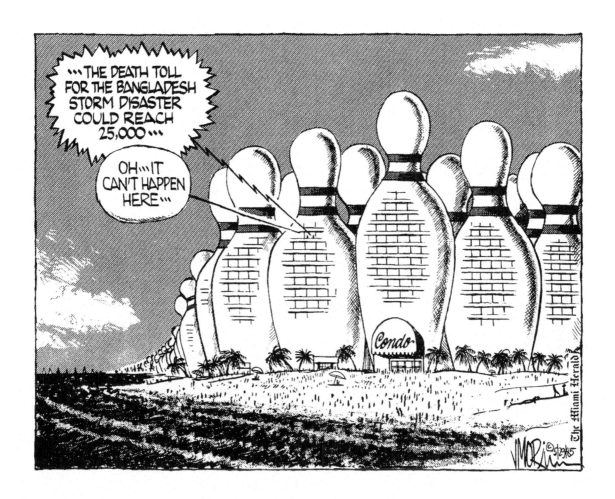

5/29/1985

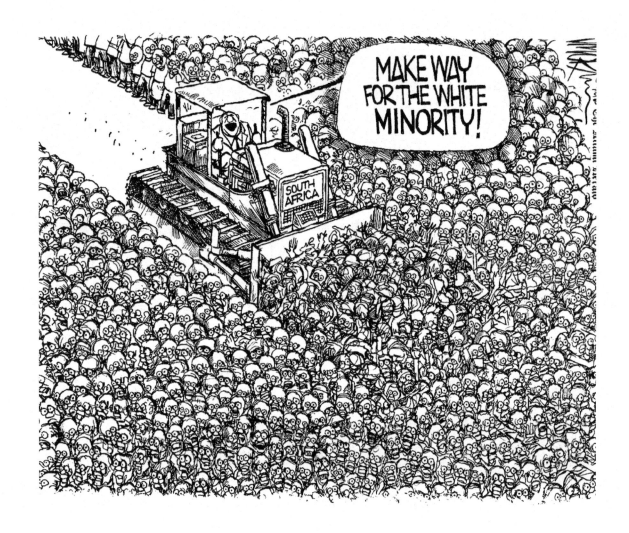

7/16/1985

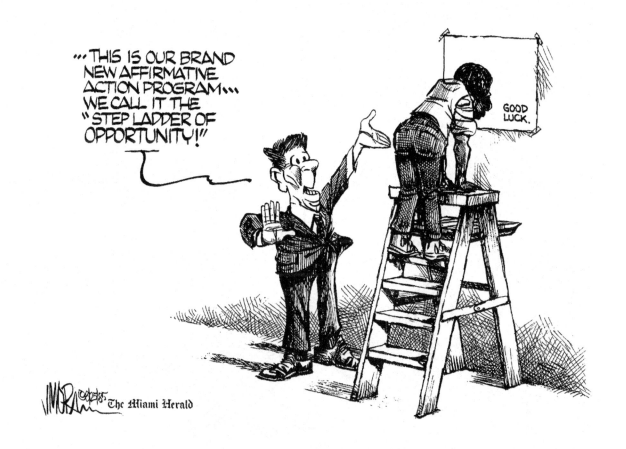

8/25/1985

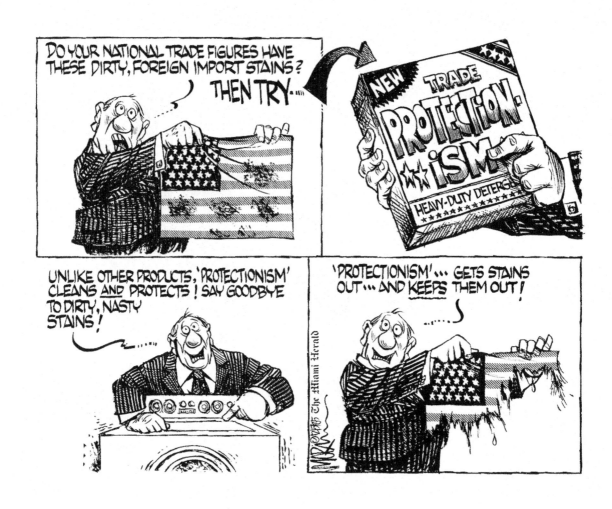

12/5/1985

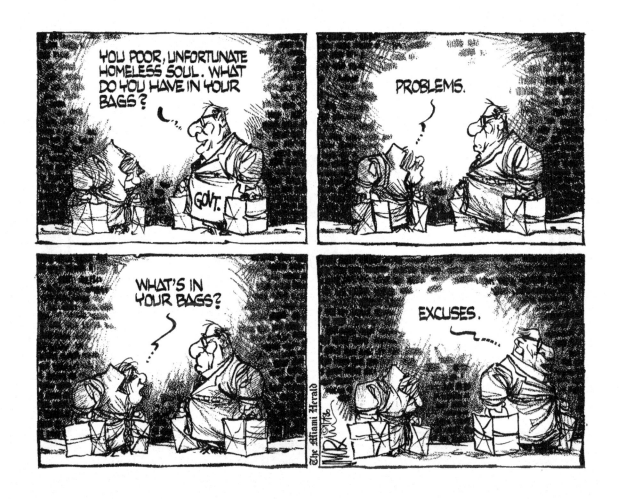

1/7/1986

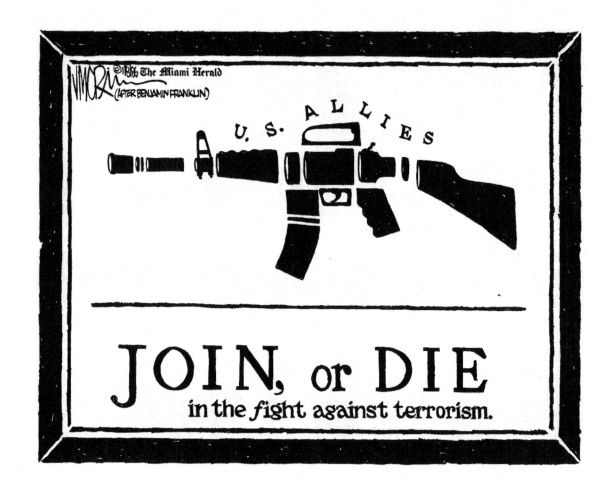

1/8/1986

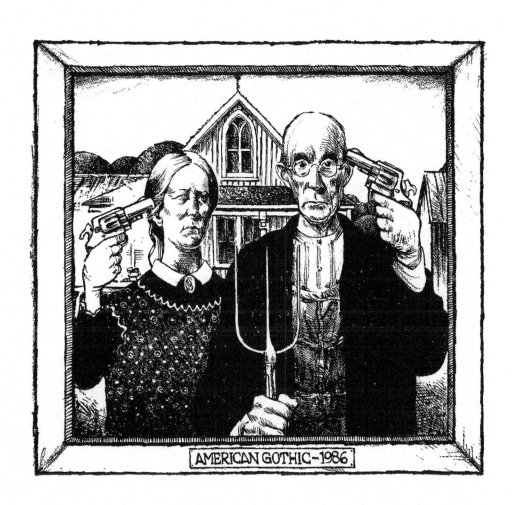

AMERICAN GOTHIC ~1986

1/12/1986

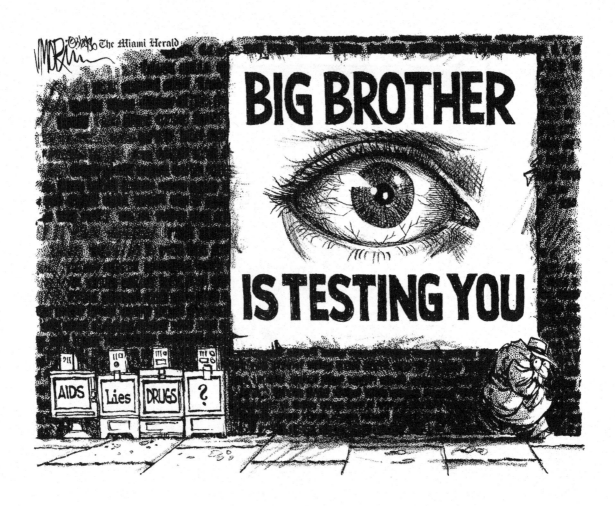

3/20/1986

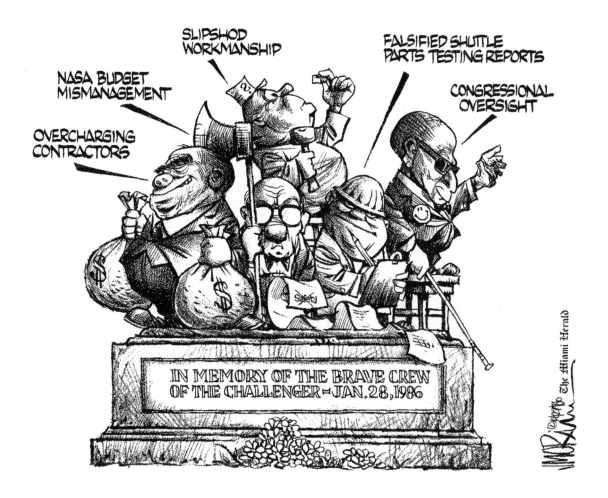

On January 28, 1986, the Space Shuttle Challenger broke apart 73 seconds into launch leading to the death of its seven crew members. It was determined that the failure of an O-ring led to the disaster.

4/27/1986

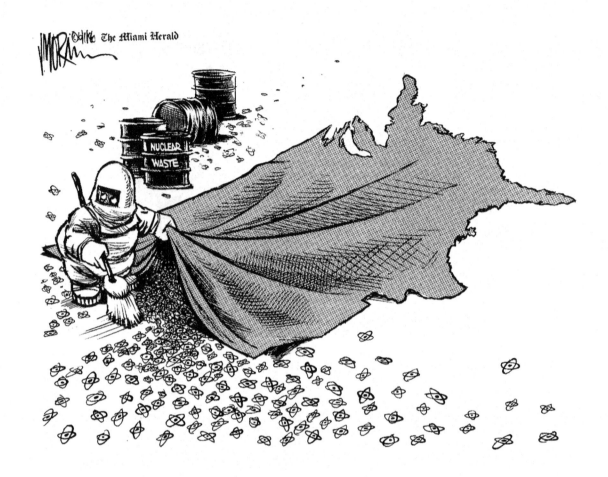

6/1/1986

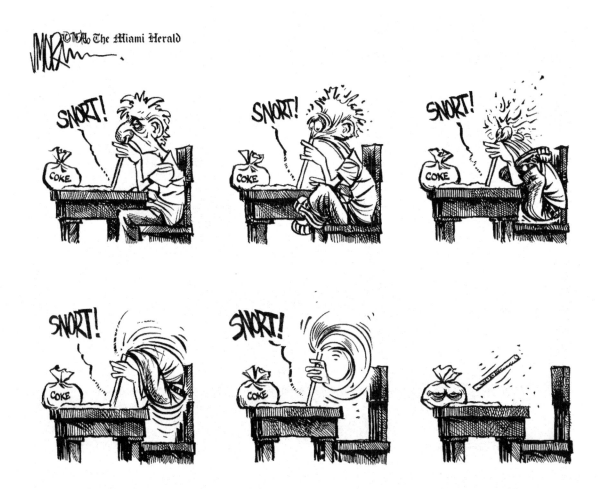

7/15/1986

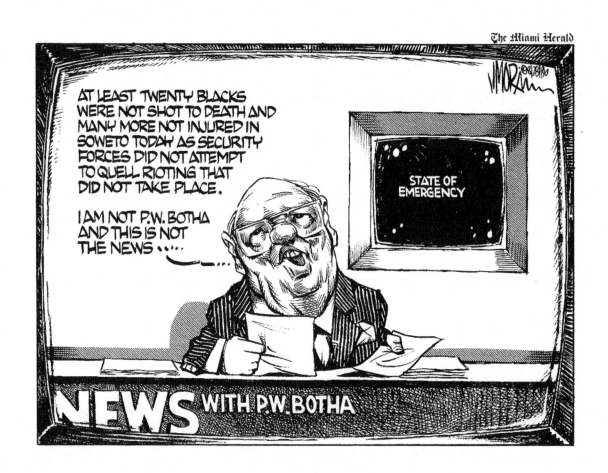

8/28/1986

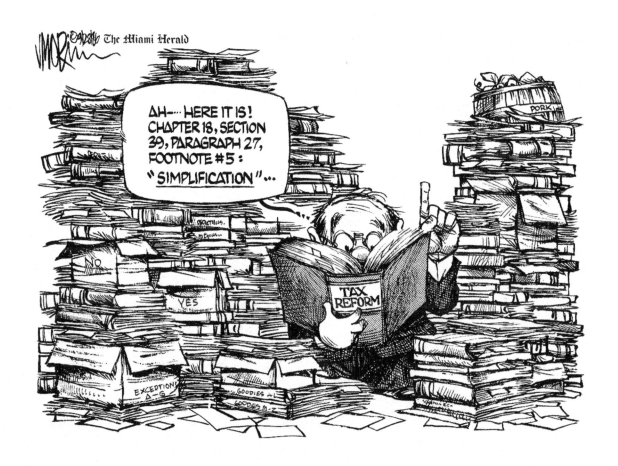

9/28/1986

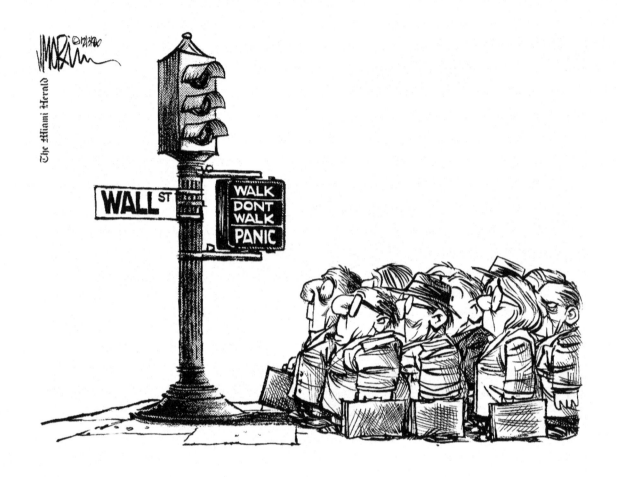

12/4/1986

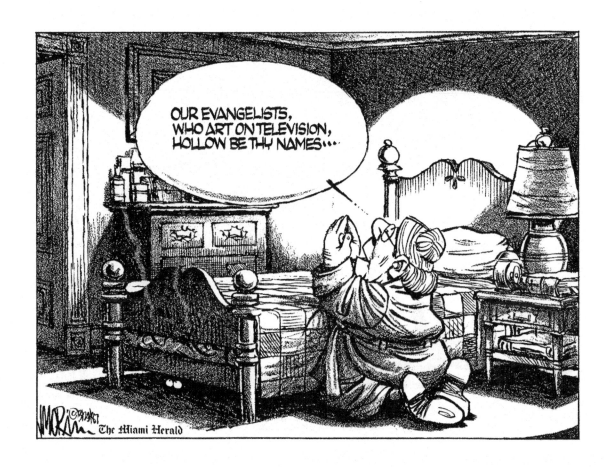

3/29/1987

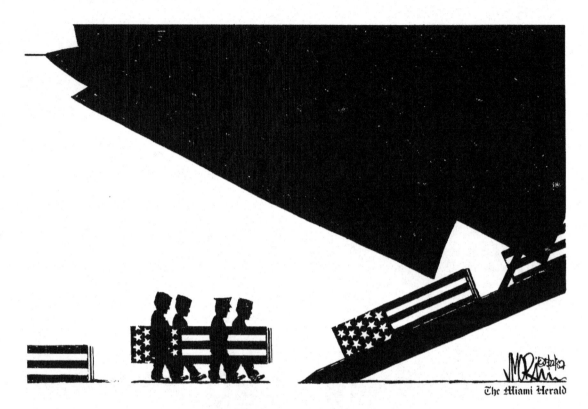

SHOWING THE FLAG ...

The Miami Herald

5/22/1987

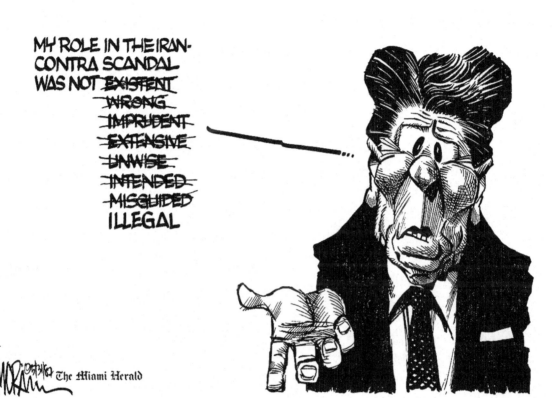

5/31/1987

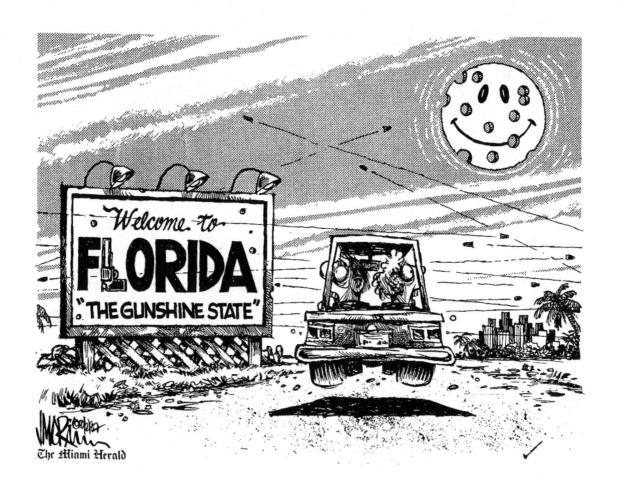

10/2/1987

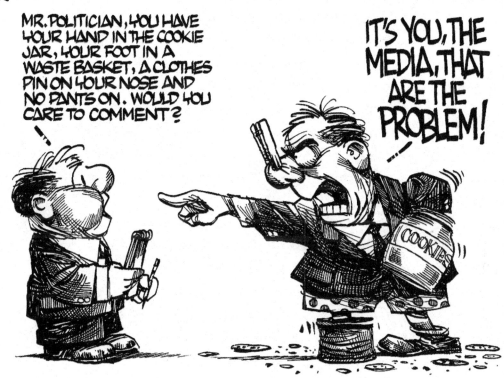

2/4/1988

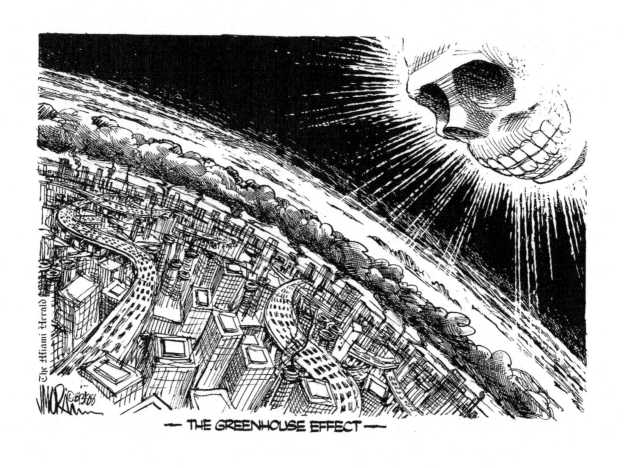

— THE GREENHOUSE EFFECT —

Later known as "Global Warming" and after that, "Climate Change"

3/3/1988

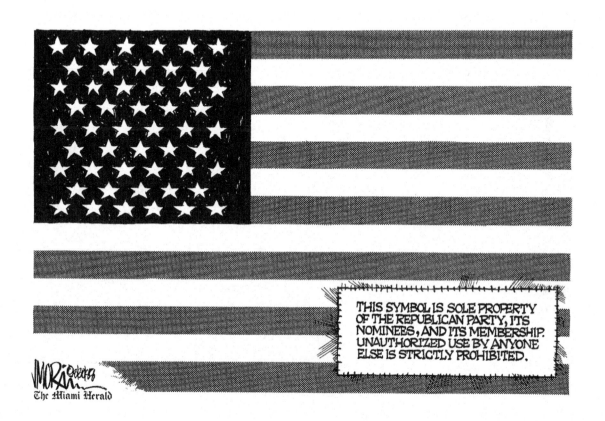

8/30/1988

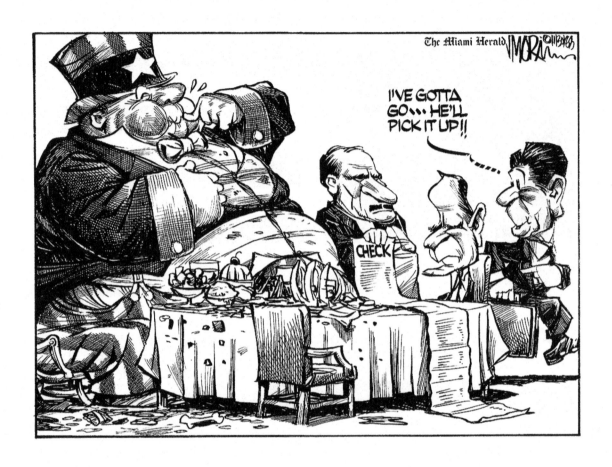

President Ronald Reagan increases the budget deficit 142% and welcomes his successor,
George H.W. Bush.

11/30/1988

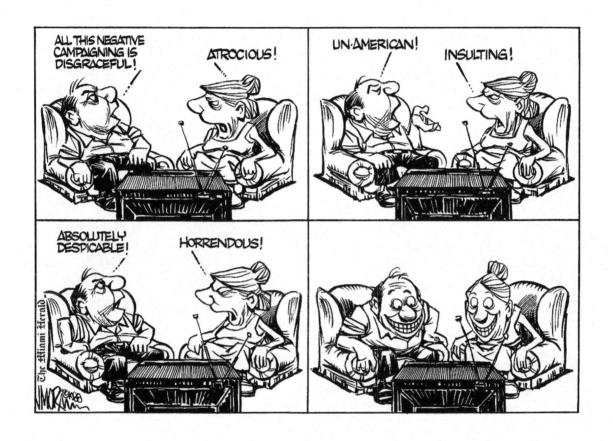

11/1988

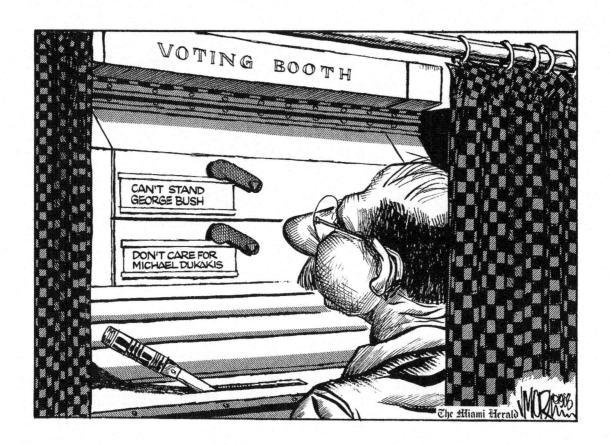

11/1988

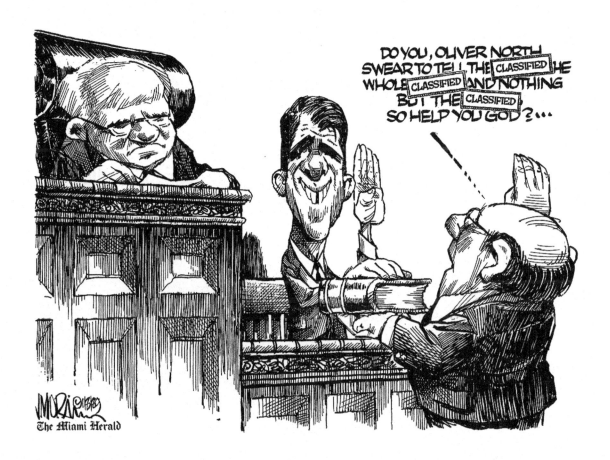

1/8/1989

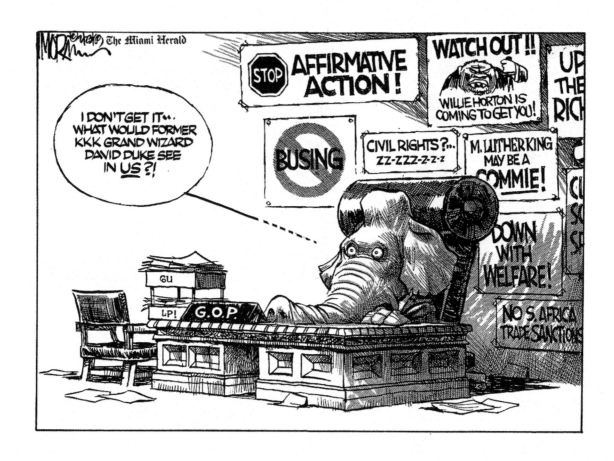

2/23/1989

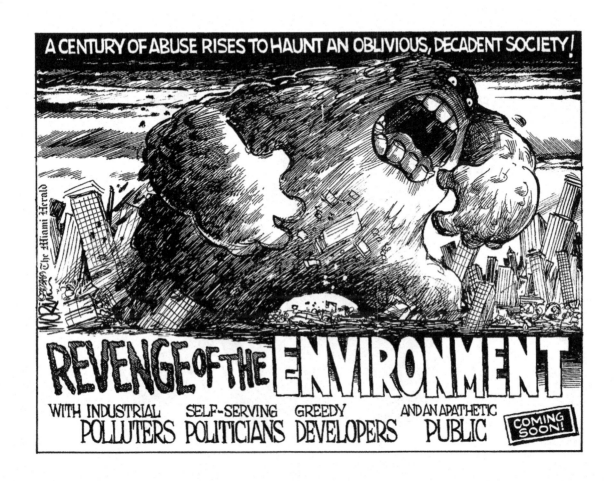

3/23/1989

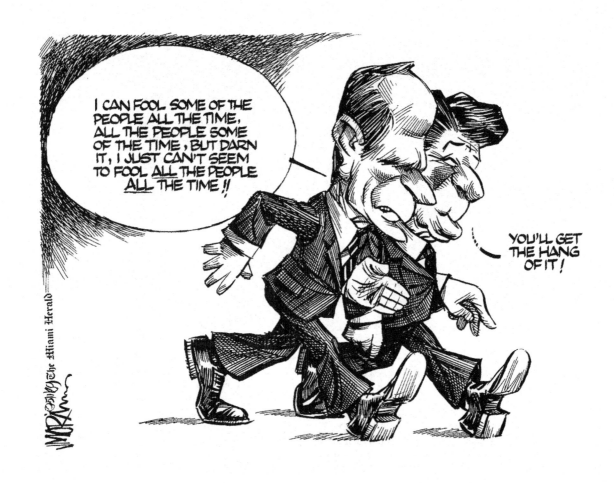

5/1/1989

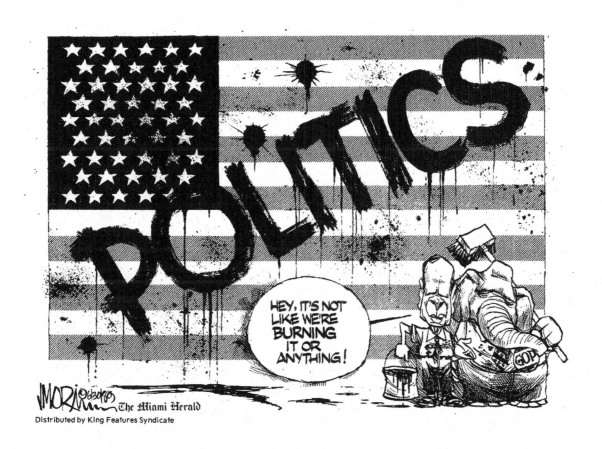

6/30/1989

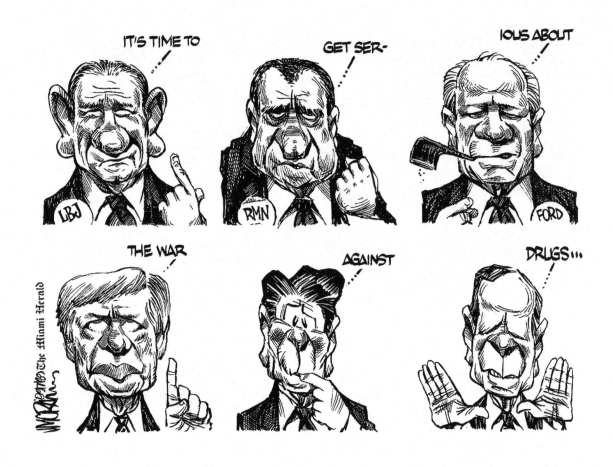

9/7/1989

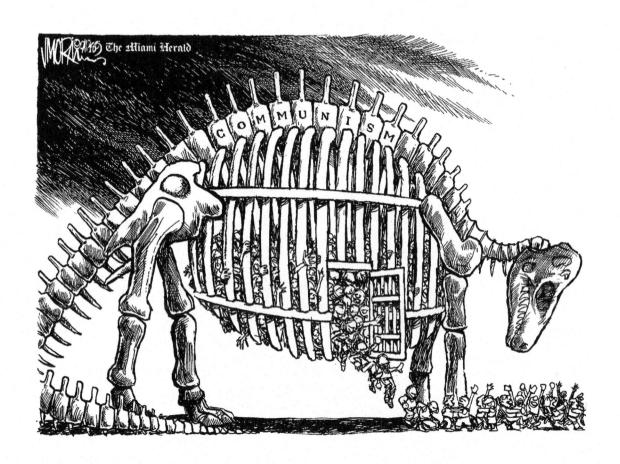

The fall of Communism.

9/13/1989

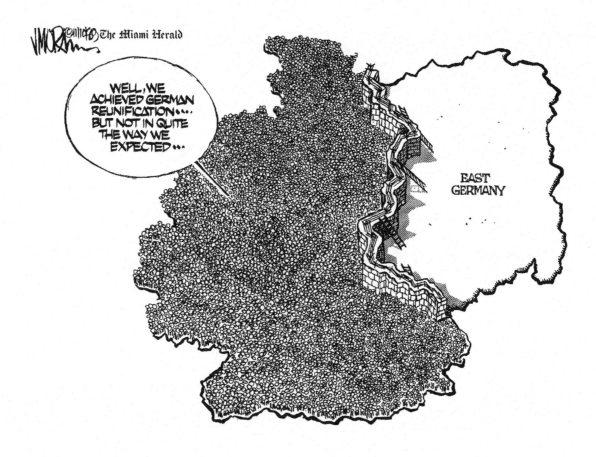

After dividing East and West Germany for 28 years, the Berlin Wall fell in November 1989. German reunification was completed on October 3, 1990. In December 1991 the Soviet Union was abolished and the Cold War officially came to an end.

11/10/1989

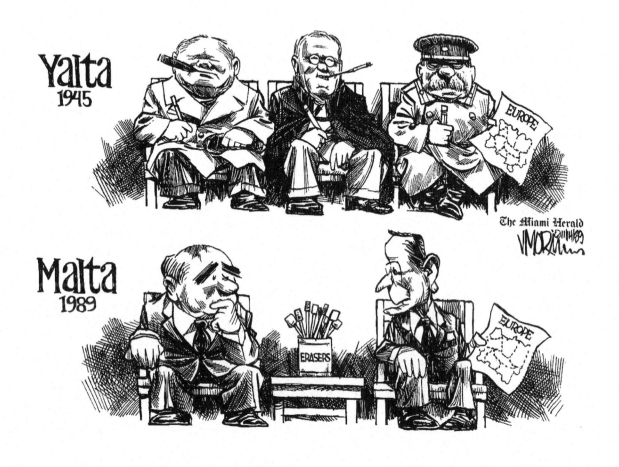

The Malta Summit with President George H.W. Bush and Soviet Premier Mikhail Gorbachev.

11/14/1989

STAGES OF LIFE

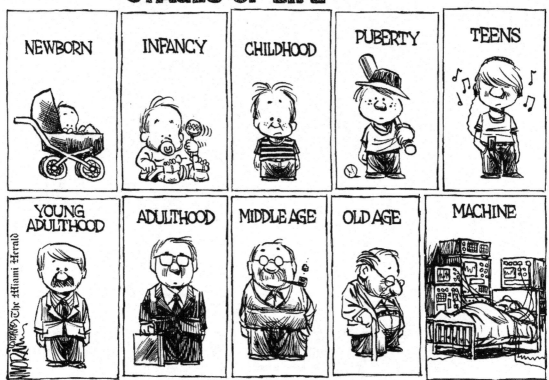

12/8/1989

1990s

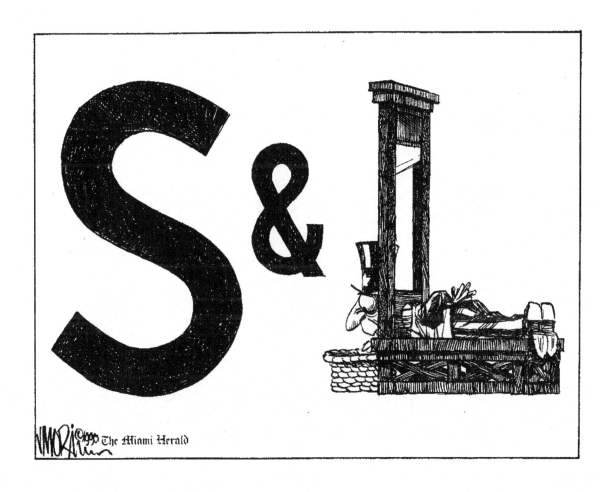

The 1986 – 1995 Savings and Loan (S&L) crisis resulted in the failure of 1,043 out of 3,234 savings and loan associations, costing the U.S. taxpayer approximately $132 billion.

1990

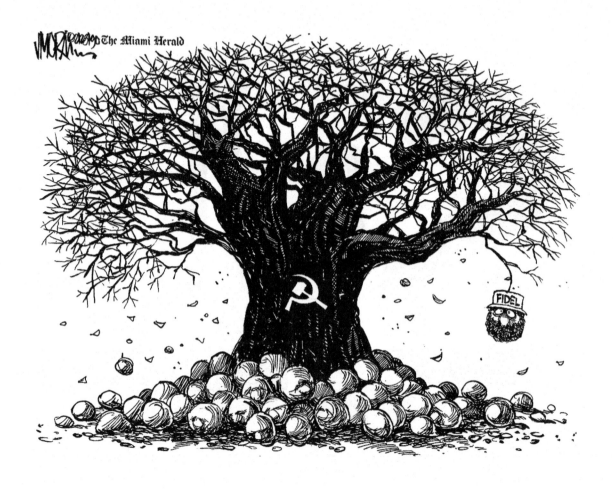

As the Soviet Union collapsed in 1990 and 1991, Fidel Castro's Cuba held to the old ways and U.S. policy toward Cuba remained in place.

2/28/1990

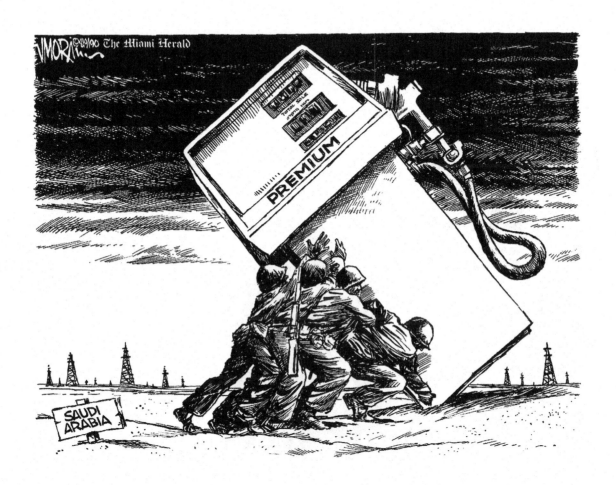

8/9/1990

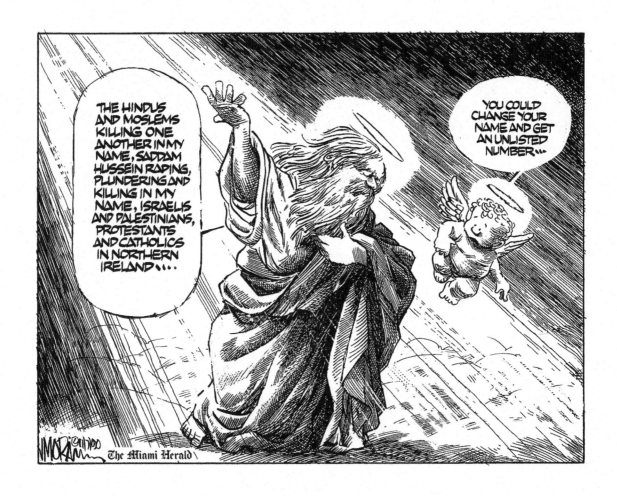

11/7/1990

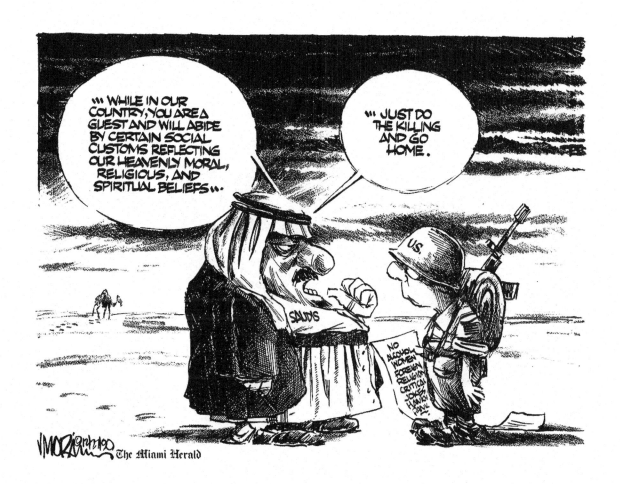

12/27/1990

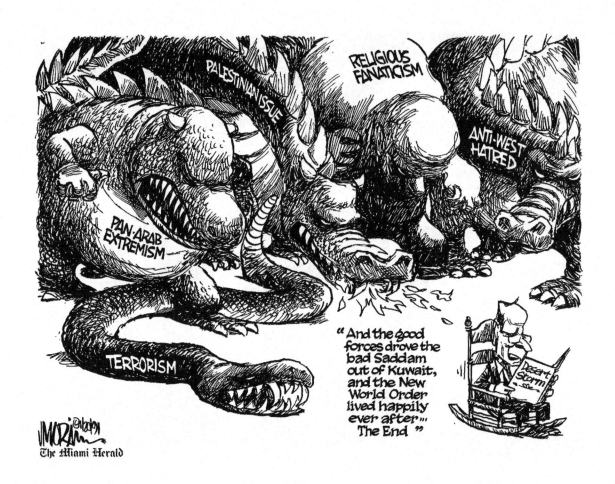

1/20/1991

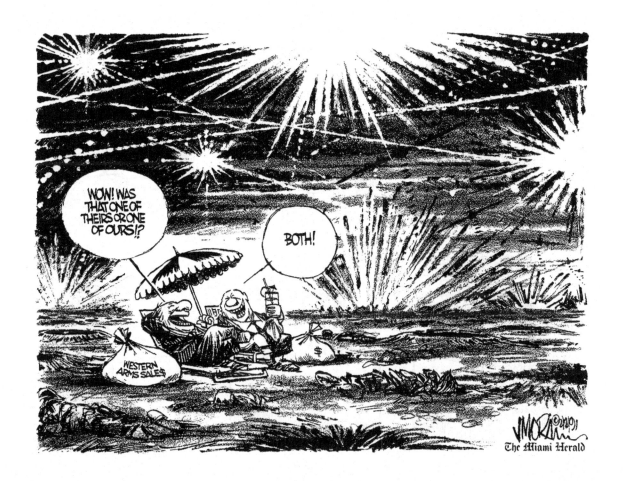

2/8/1991

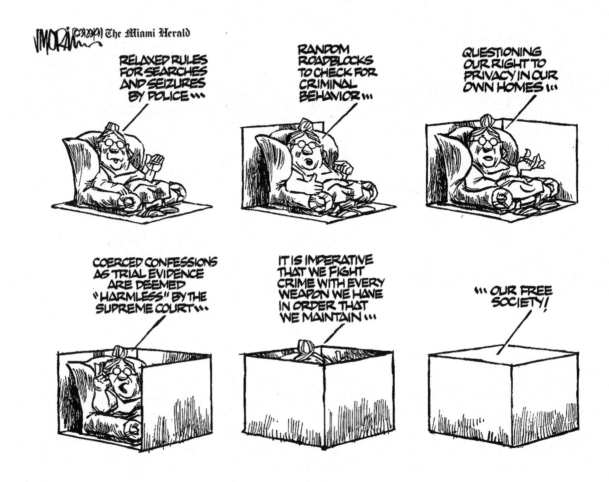

3/29/1991

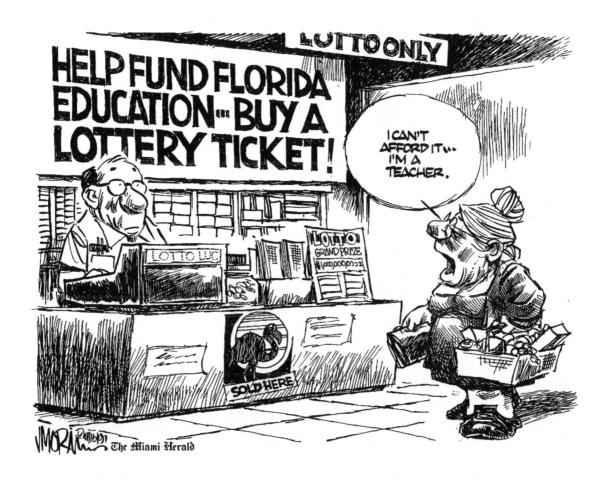

4/16/1991

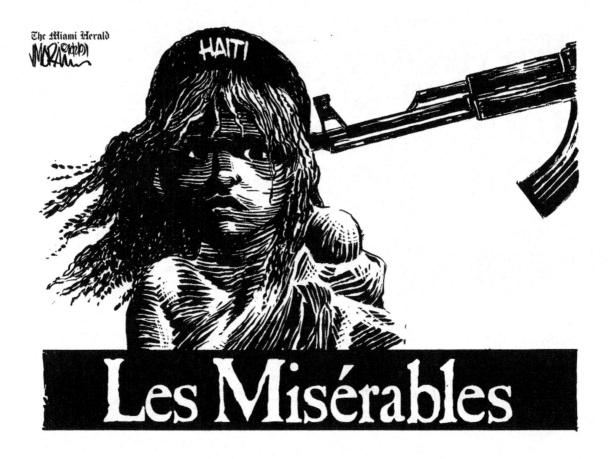

On September 30, 1991, the Haitian military under Lieutenant General Raoul Cedras overthrew Jean-Bertrand Aristide, the country's first freely elected president. President Bush strongly condemned the military coup in Haiti, and on October 1, suspended U.S. economic and military aid and demanded the immediate return to power of President Jean-Bertrand Aristide.

10/2/1991

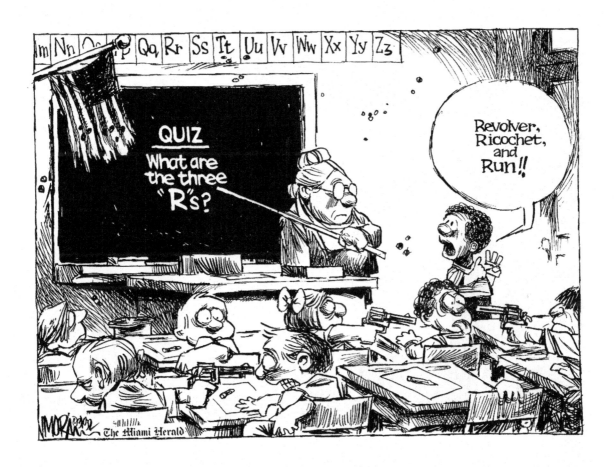

3/1992

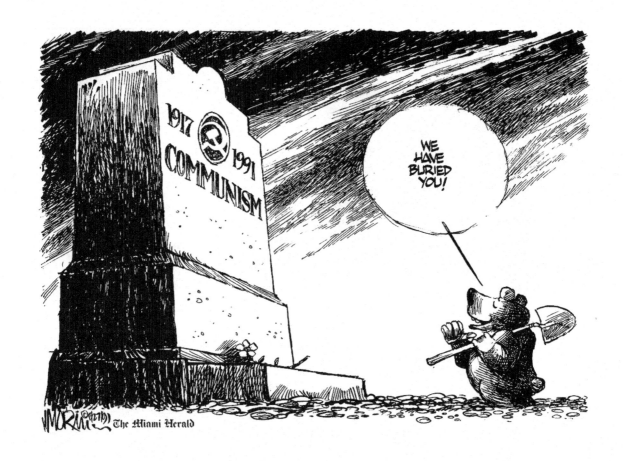

8/27/1992

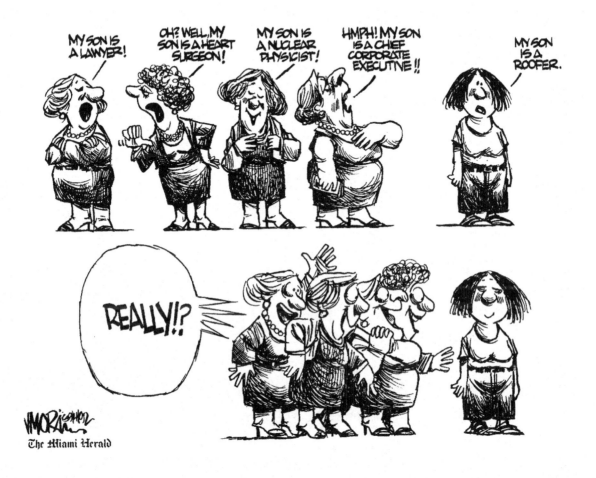

Roofers were in demand after Category 5 Hurricane Andrew damaged or destroyed more than 125,000 Florida homes and left about 250,000 people homeless in south Miami-Dade County in August 1992.

9/4/1992

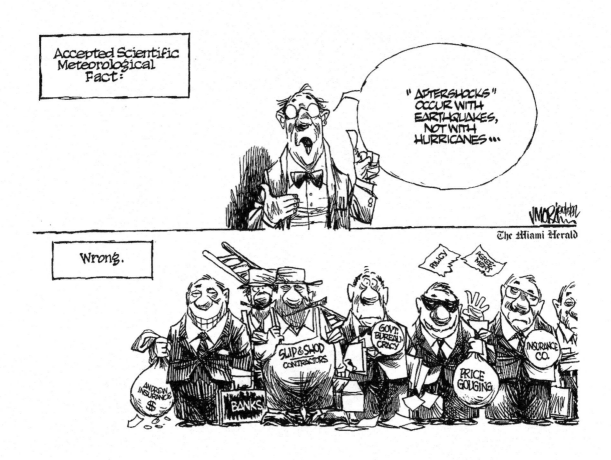

12/15/1992

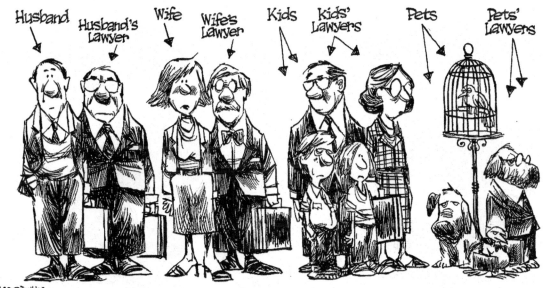

4/7/1993

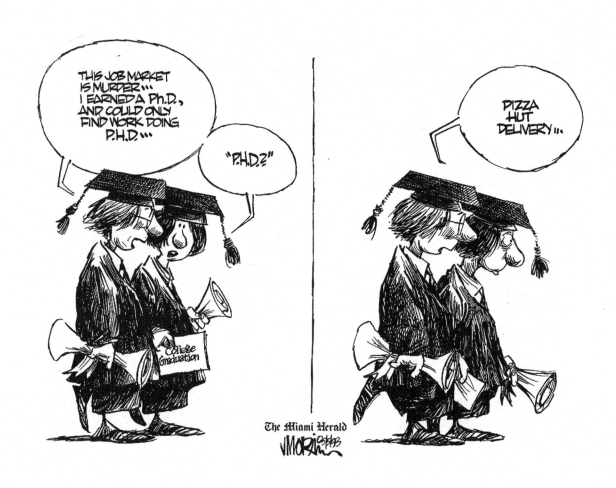

5/5/1993

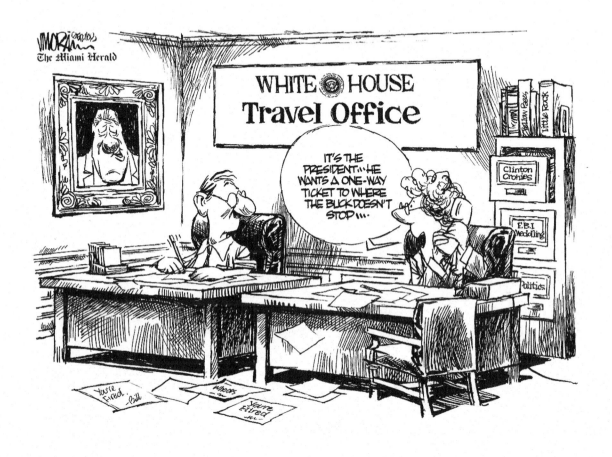

Seven employees of the White House Travel Office were fired in May 1993 for financial improprieties and replaced with friends of Bill and Hillary. Heavy media attention forced the reinstatement of most of the fired employees in other jobs and the removal of Clinton associates from the Travel Office

5/27/1993

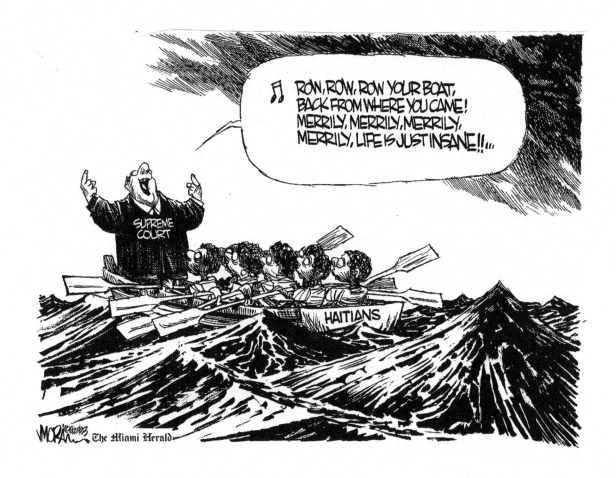

In June 1993, the Supreme Court ruled that Haitian boat people could be stopped at sea and returned home without asylum hearings.

6/23/1993

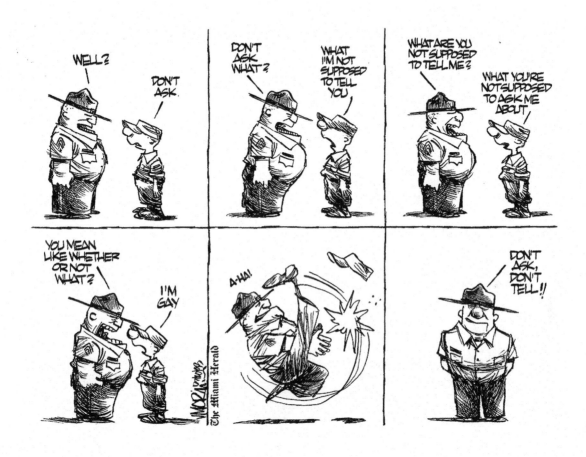

"Don't ask, don't tell" was the official U.S. policy on military service by gays, bisexuals, and lesbians, instituted by the Clinton Administration by 1994.

7/20/1993

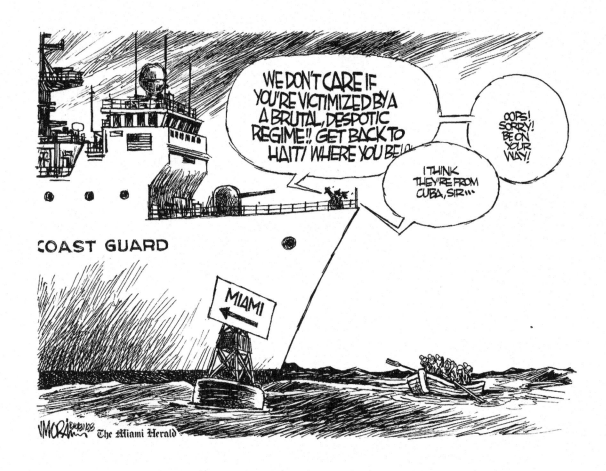

Both Cuba and Haiti sent floods of refugees to the U.S. in the 1980s and '90s. The U.S. had long had a policy of accepting Cuban refugees as victims of political oppression, but most Haitian refugees were seen as fleeing poverty and not political oppression.

10/31/1993

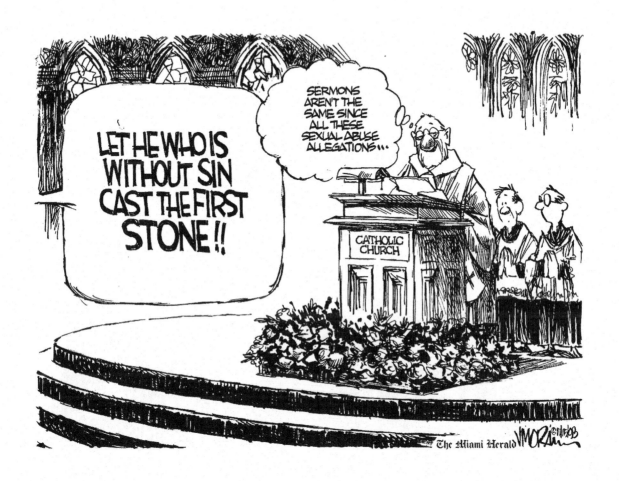

11/15/1993

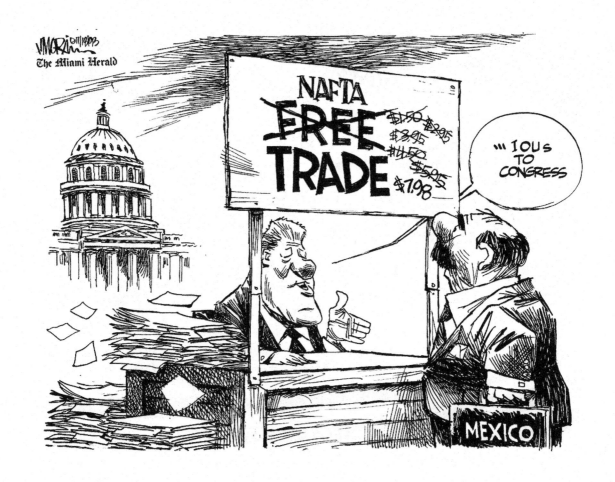

11/18/1993

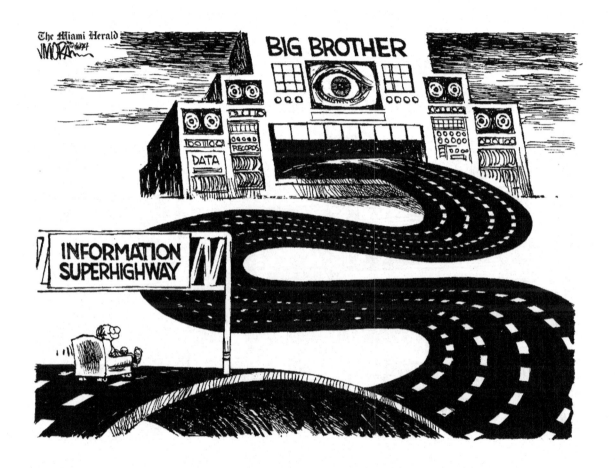

1/6/1994

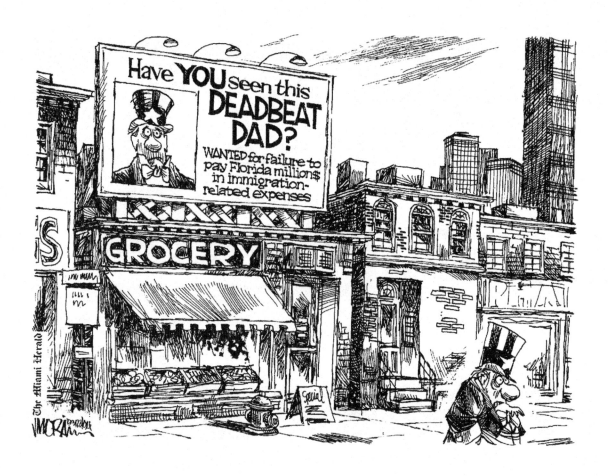

3/22/1994

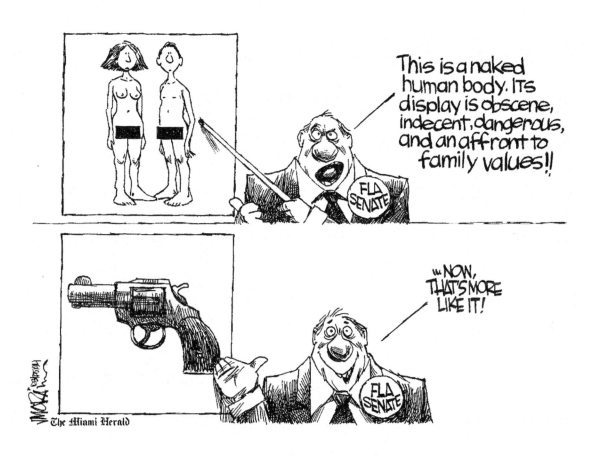

3/25/1994

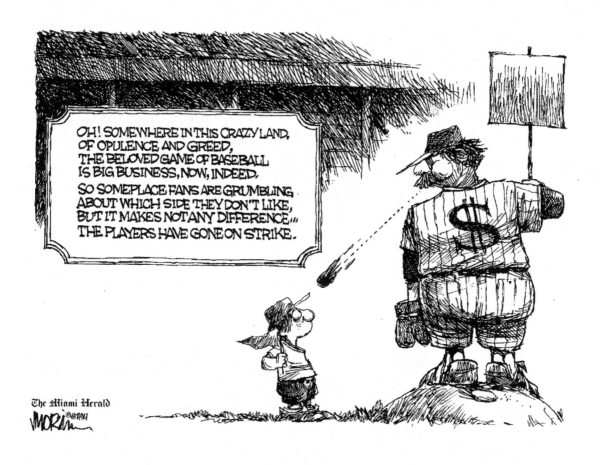

The 232 day 1994-95 Major League Baseball strike was the longest baseball work stoppage in history. It started on August 12, 1994, ending the remainder of that season, postseason, and World Series.

8/12/1994

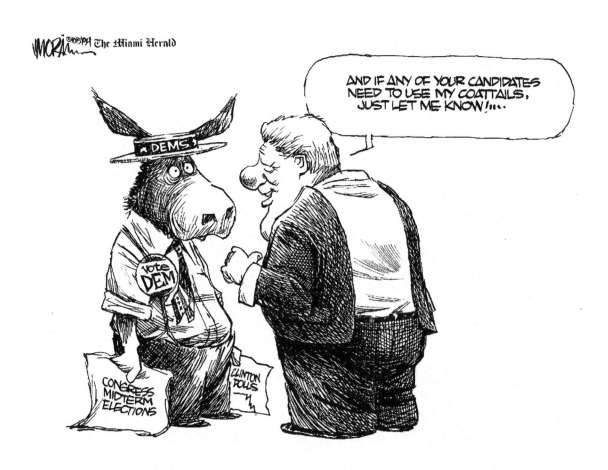

10/5/1994

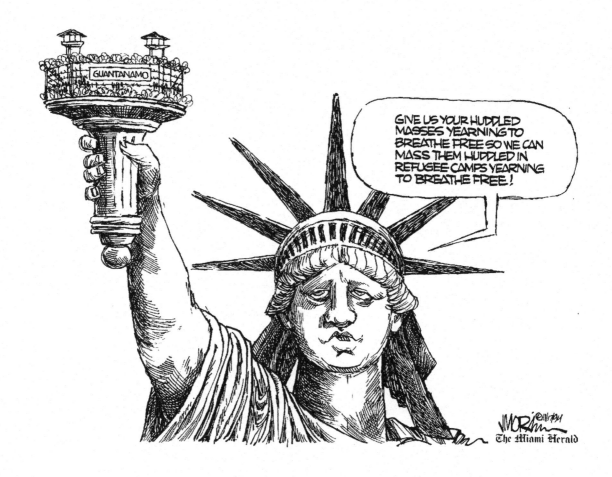

11/17/1994

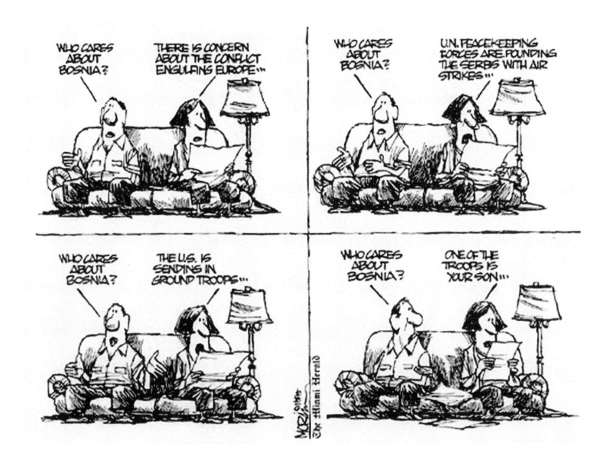

1996 Pulitzer cartoon

In December 1995, President Bill Clinton authorized the first deployment of U.S. troops to Bosnia to help lay the ground work for an international peacekeeping force of thousands.

1/6/1995

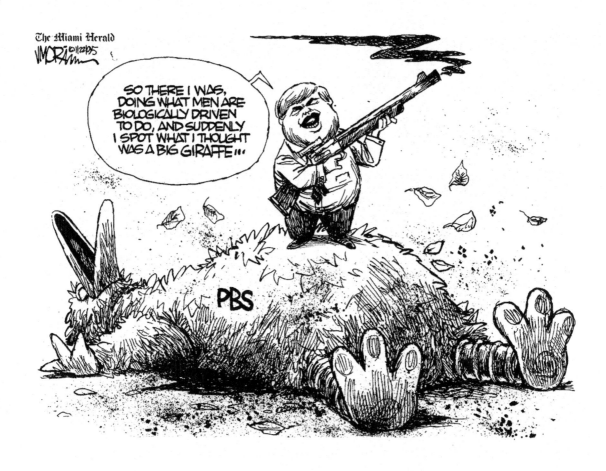

1996 Pulitzer cartoon

Newly anointed House Speaker Newt Gingrich makes defunding the Corporation for Public Broadcasting, which he describes during a news conference as a "little sandbox for the rich," a main legislative goal.

1/22/1995

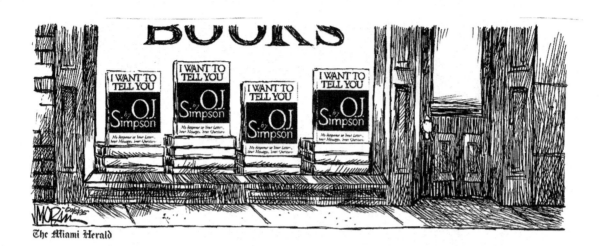

I WISH I COULD
TELL YOU

by NICOLE
Simpson

1996 Pulitzer cartoon

I Want to Tell You, by O. J. Simpson, was published in January 1995 during OJ's trial for the murder of his wife Nicole.

2/5/1995

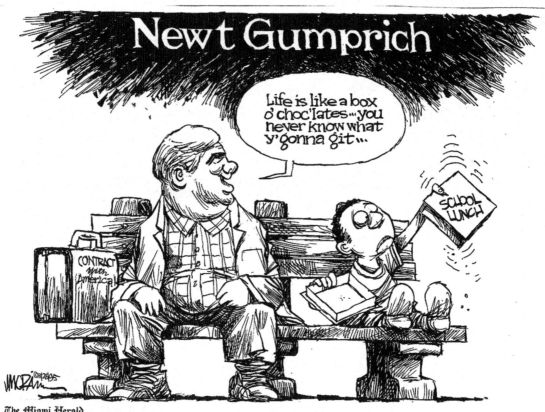

The Miami Herald

1996 Pulitzer cartoon

Proposed under Newt Gingrich's Contract With America, the Republicans would give each state a lump sum of money to help schools feed children. This block grant was to replace the school lunch program, and the separate school breakfast program.

3/28/1995

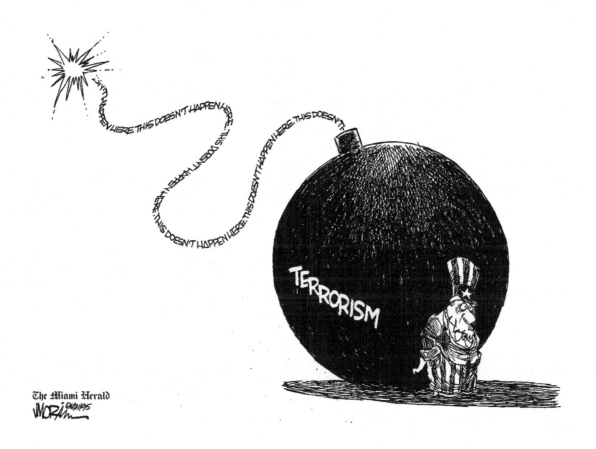

4/21/1995

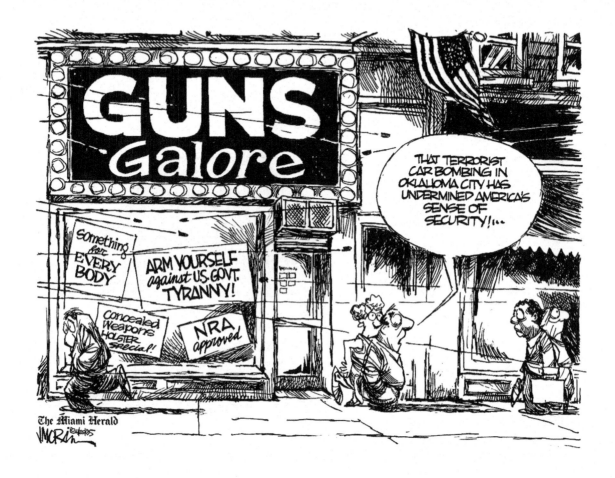

1996 Pulitzer cartoon

4/25/1995

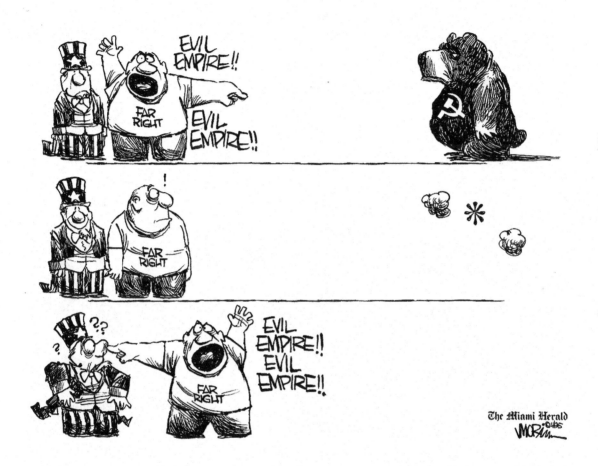

1996 Pulitzer cartoon

The phrase "Evil Empire" was coined by President Ronald Reagan in 1983.

4/1995

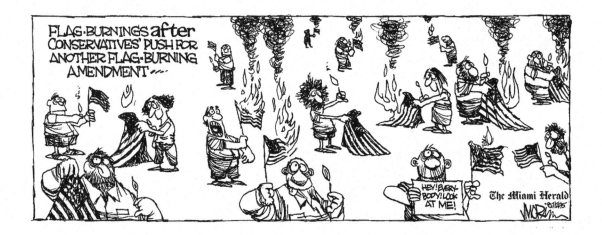

1996 Pulitzer cartoon

7/2/1995

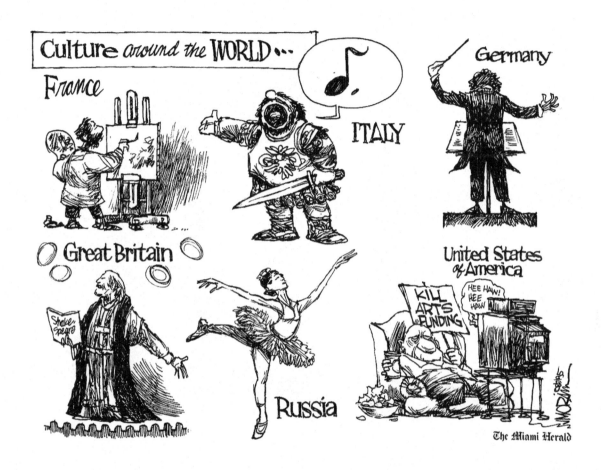

1996 Pulitzer cartoon

8/7/1995

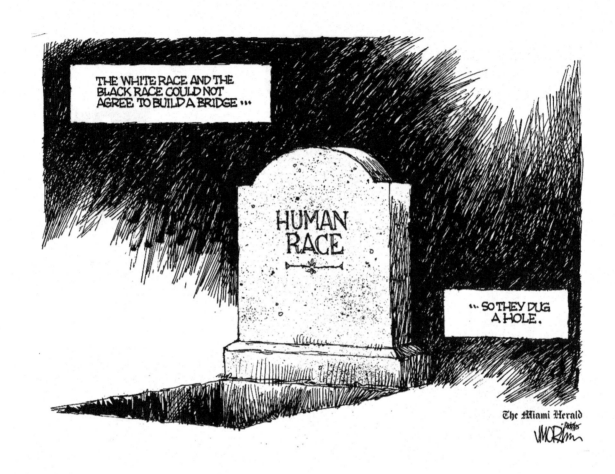

1996 Pulitzer cartoon

10/7/1995

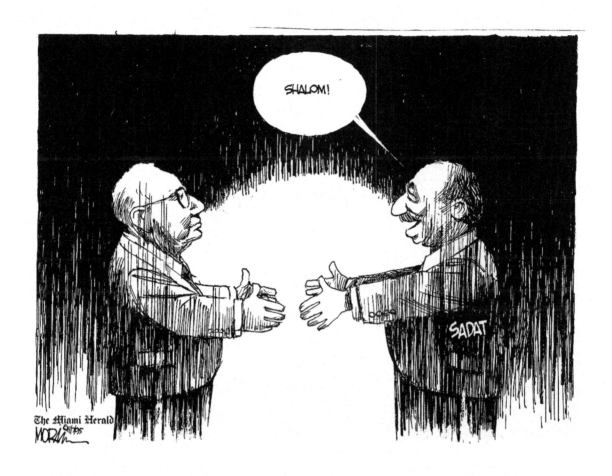

1996 Pulitzer cartoon

The Oslo II Accord was signed on September 28, 1995 by Israeli Prime Minister Yitzhak Rabin and PLO Chairman Yasser Arafat and witnessed by President Bill Clinton in Washington, D.C.

11/7/1995

113

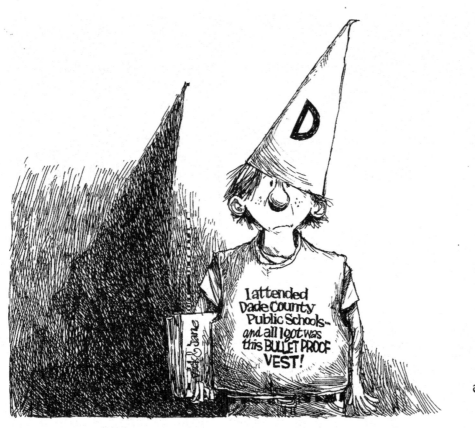

1/24/1996

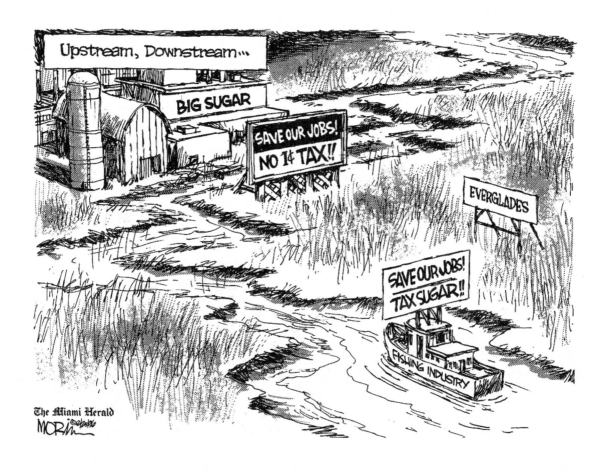

2/25/1996

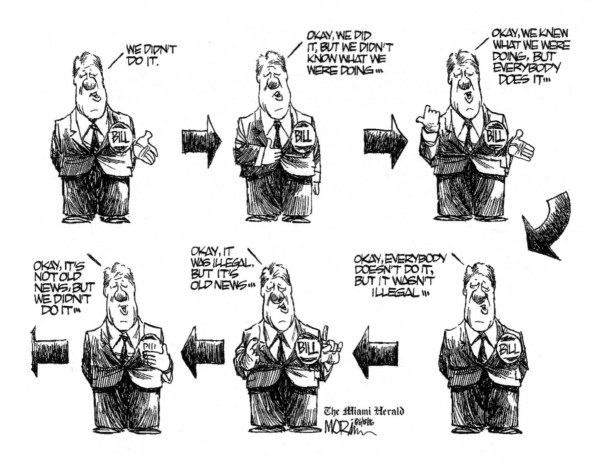

6/18/1996

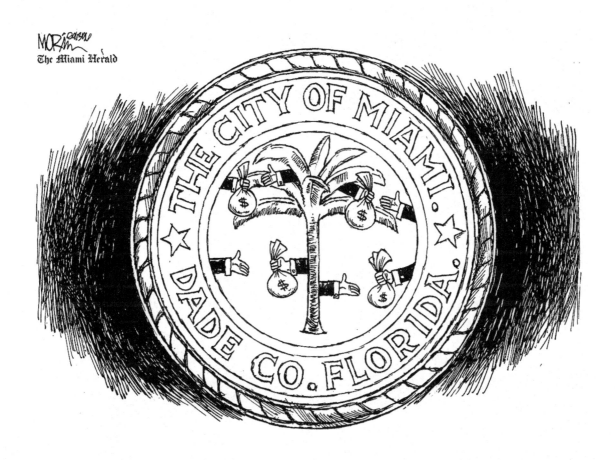

A Federal corruption probe reveals widespread corruption in Miami city government.

9/13/1996

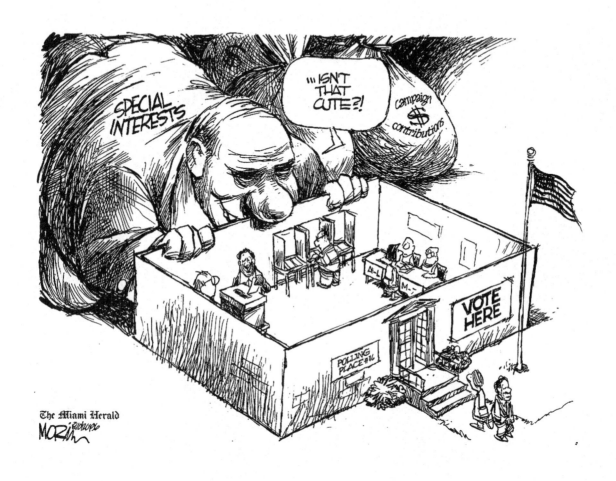

10/20/1996

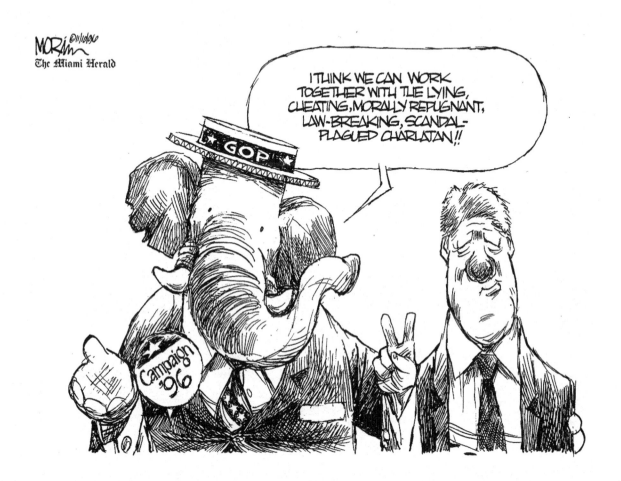

11/10/1996

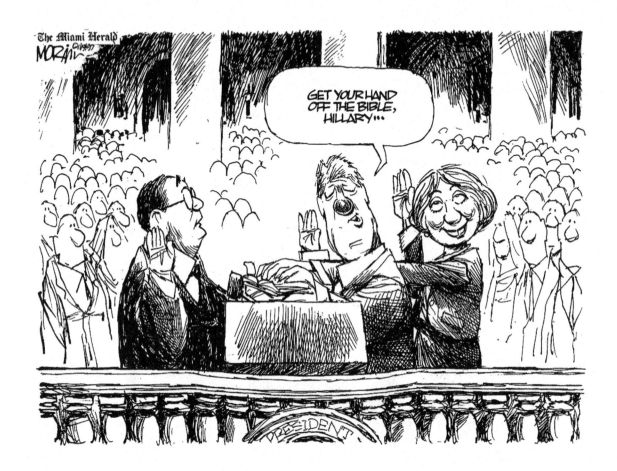

1/9/1997

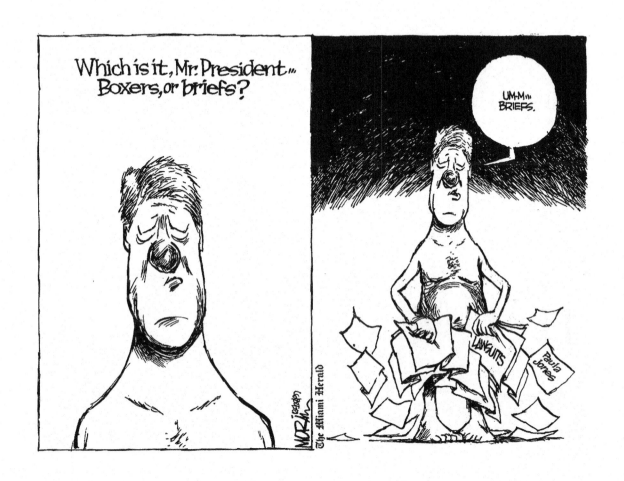

5/28/1997

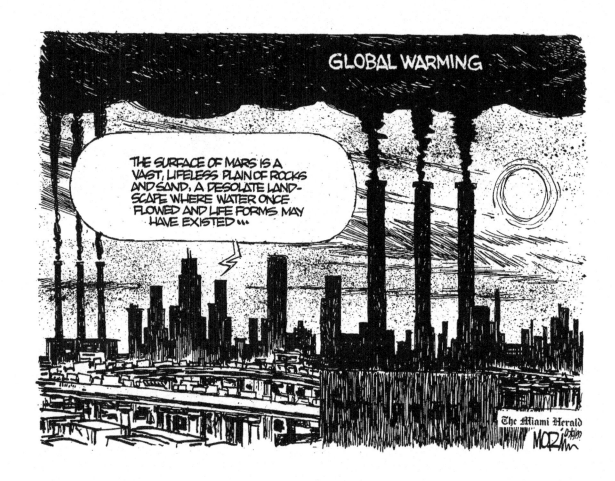

7/9/1997

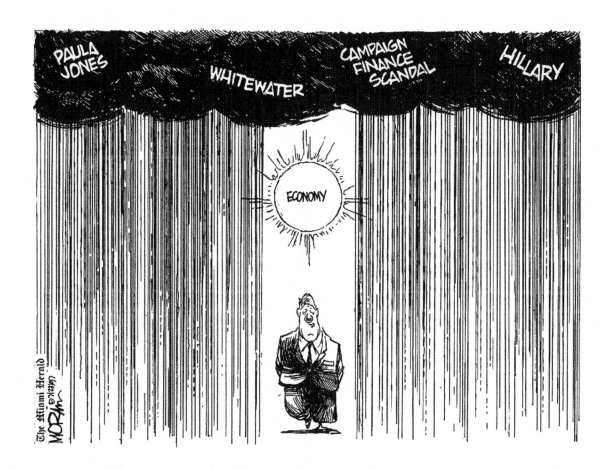

7/23/1997

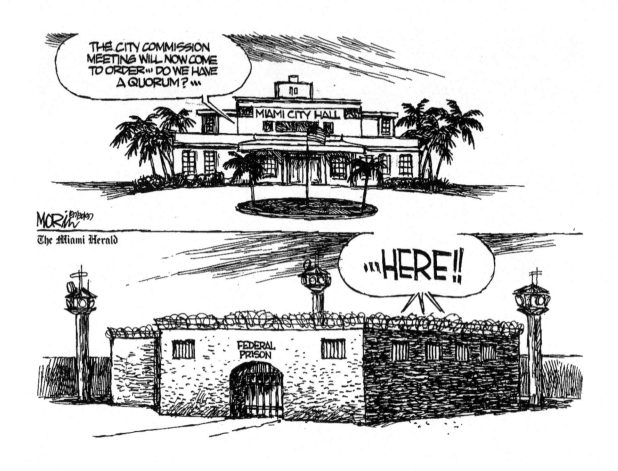

7/30/1997

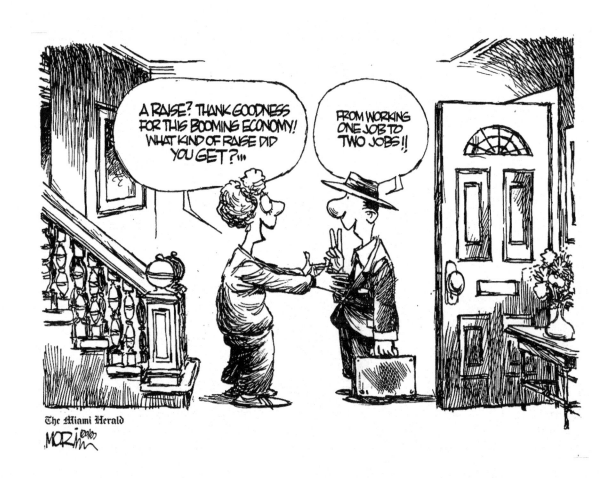

9/1997

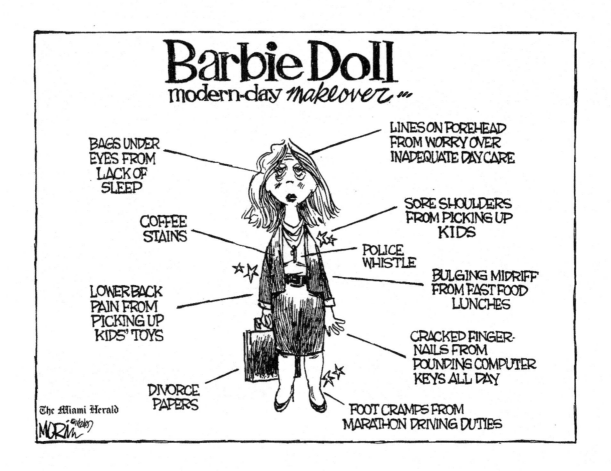

11/21/1997

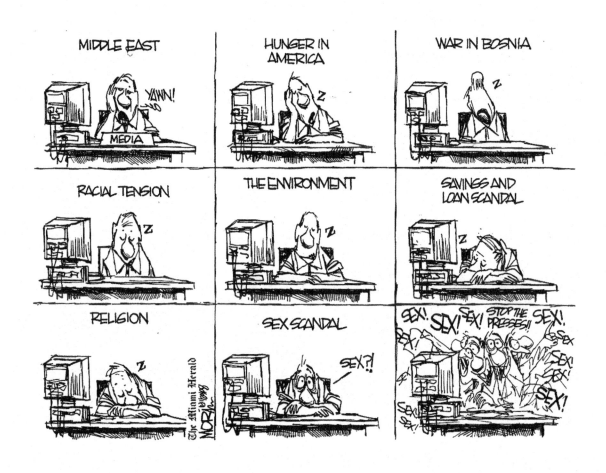

1/29/1998

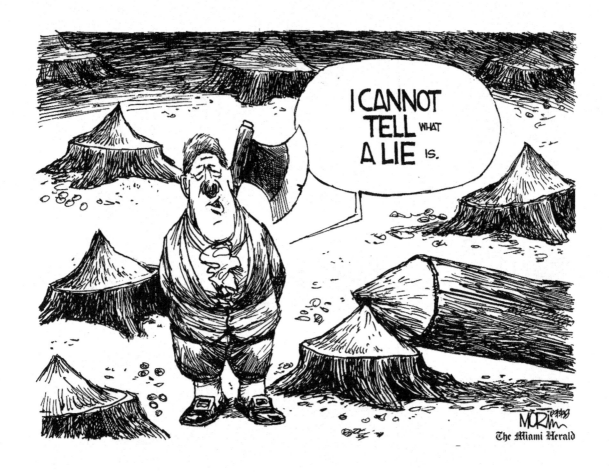

3/3/1998

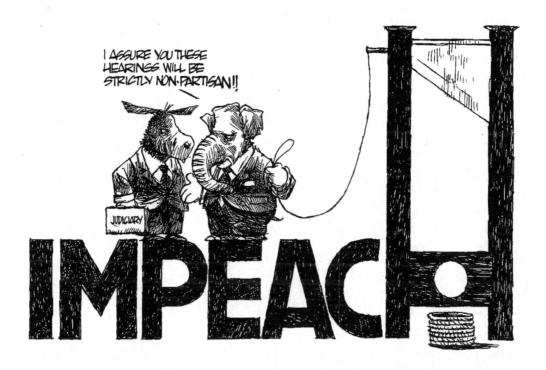

10/4/1998

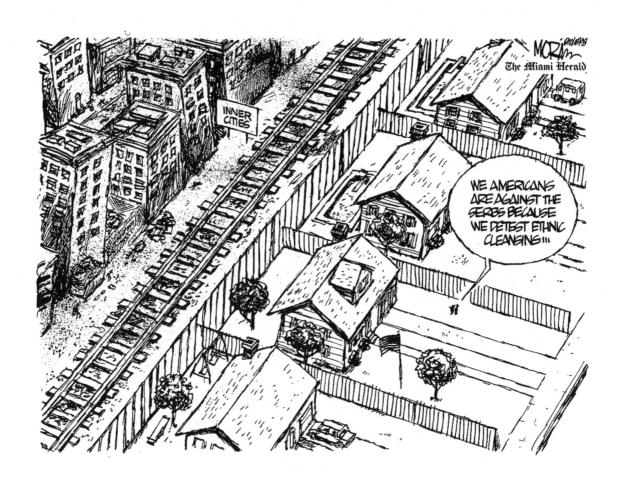

10/18/1998

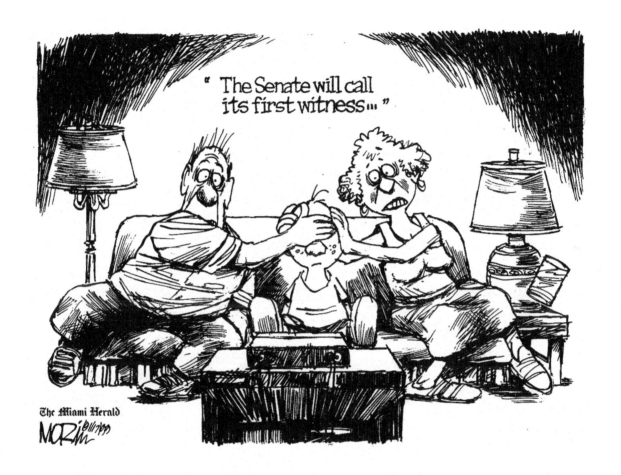

1/17/1999

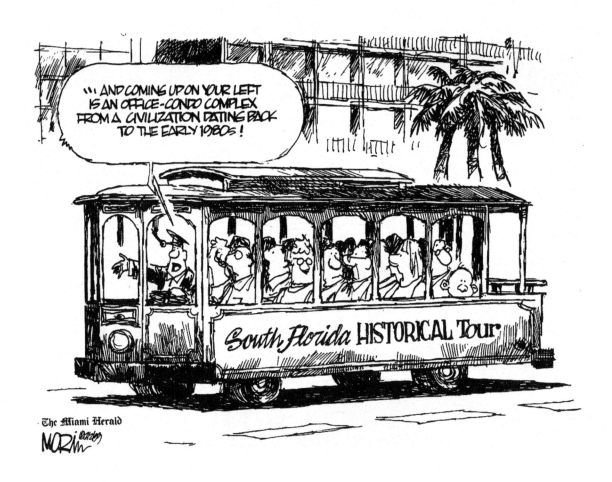

2/2/1999

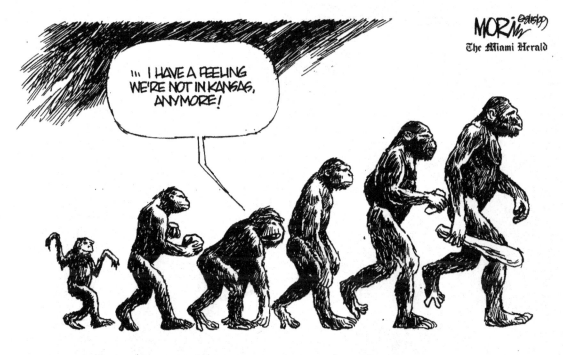

Kansas Board Of Education votes to delete any mention of evolution from its schools' science curriculum.

8/15/1999

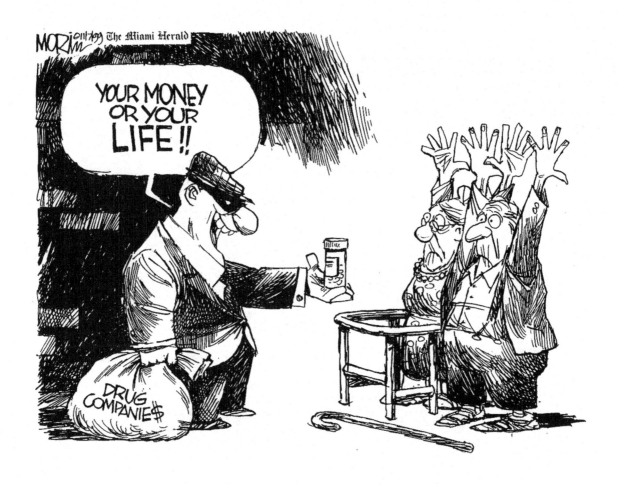

11/7/1999

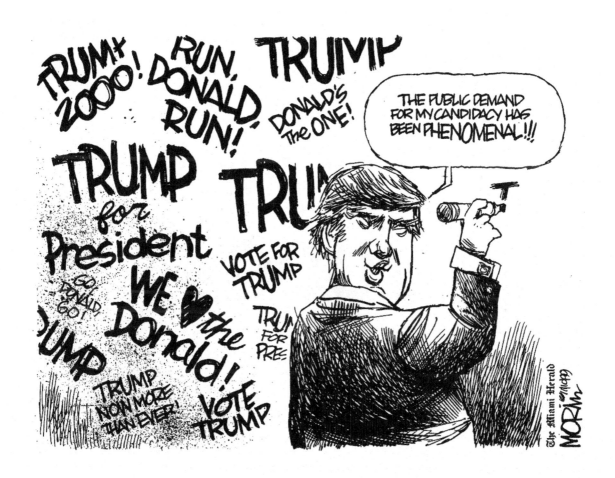

11/10/1999

2000s

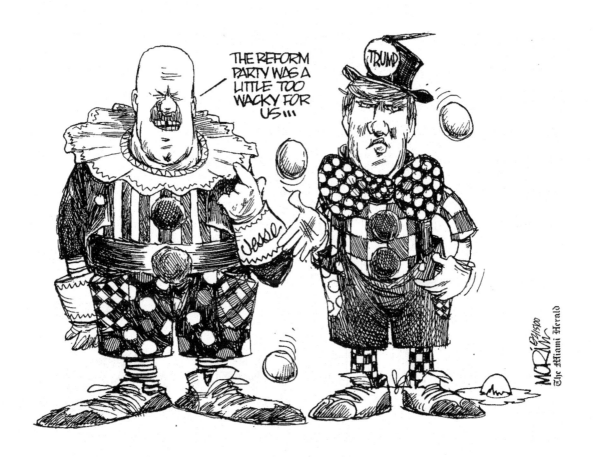

Minnesota governor Jesse Ventura persuades Trump to seek reform party nomination.

2/15/2000

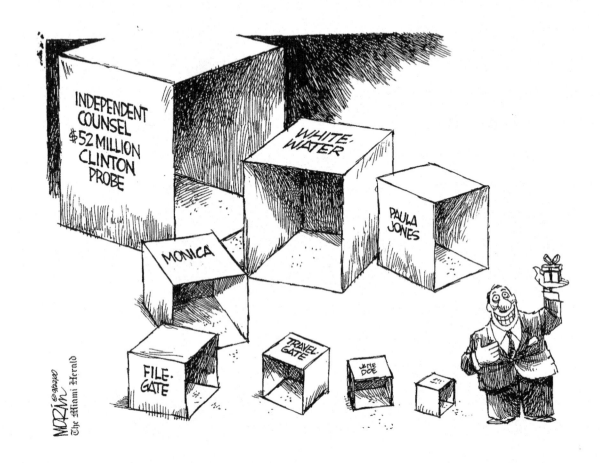

9/22/2000

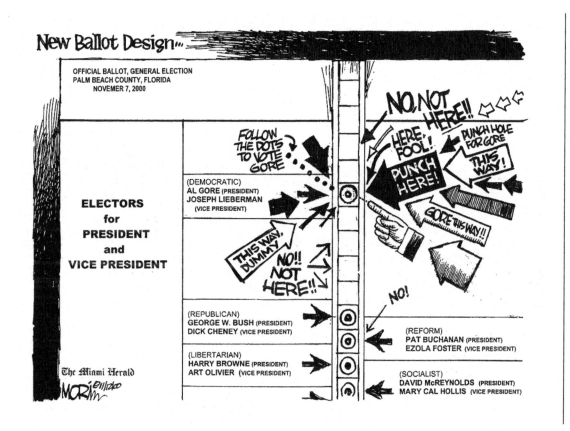

In the 2000 election, 537 Florida votes separated George W. Bush and Al Gore.
In Palm Beach county, some blamed the ballot.

11/12/2000

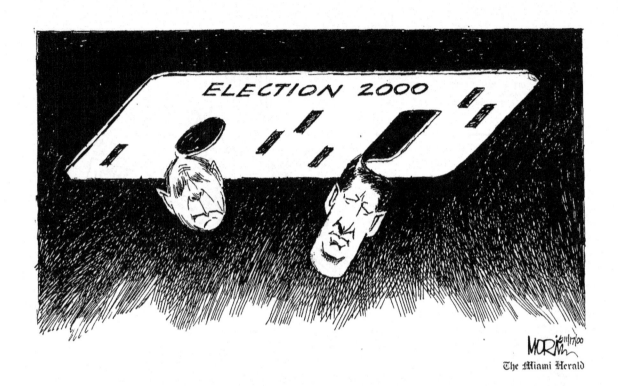

ELECTION 2000

The Miami Herald

HANGING CHADS...

The slim margin mandated a ballot recount.....

11/17/2000

One Man, One Vote.

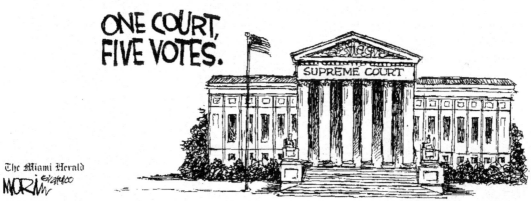

ONE COURT, FIVE VOTES.

SUPREME COURT

The Miami Herald

MORIN

....ultimately decided by the conservative majority on the Supreme Court.

12/14/2000

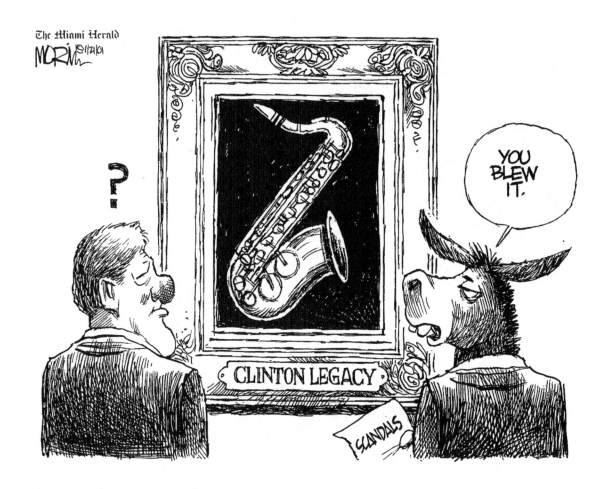

1/21/2001

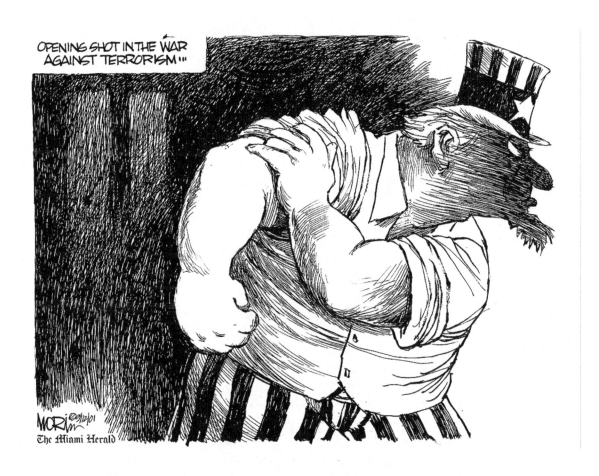

Terrorists attack the World Trade Center on 9/11. We were warned.

9/12/2001

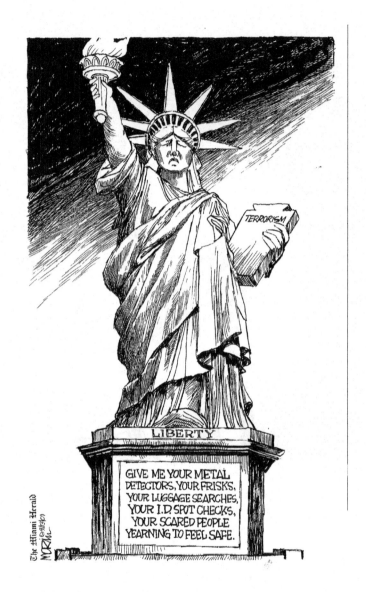

TERRORISM

LIBERTY

GIVE ME YOUR METAL
DETECTORS, YOUR FRISKS,
YOUR LUGGAGE SEARCHES,
YOUR I.D. SPOT CHECKS,
YOUR SCARED PEOPLE
YEARNING TO FEEL SAFE.

The Miami Herald

9/13/2001

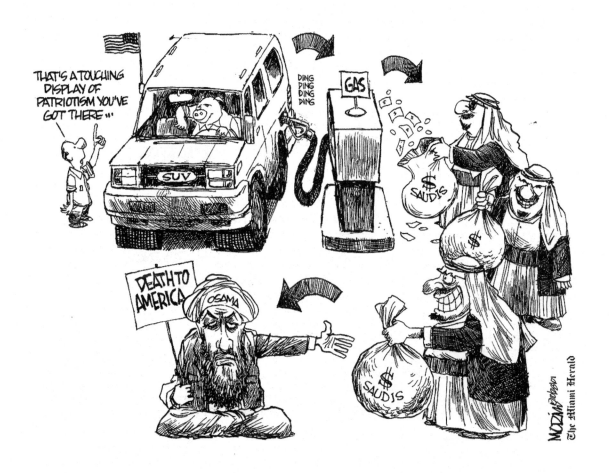

10/28/2001

145

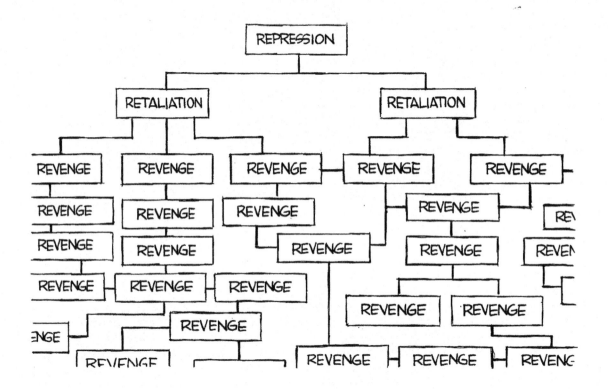

12/2/2001

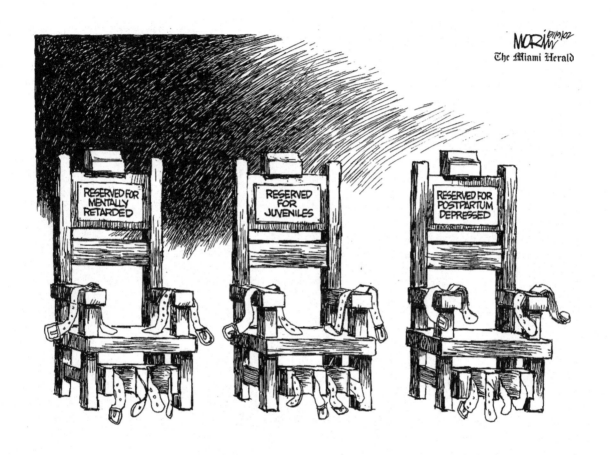

1/9/2002

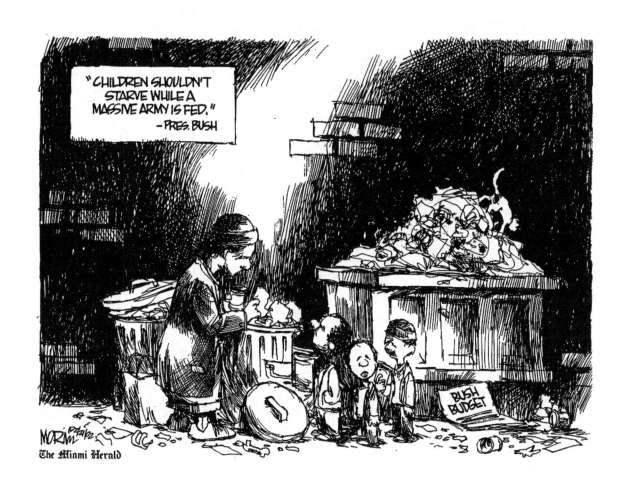

Major increase in defense spending – 2002 budget

2/21/2002

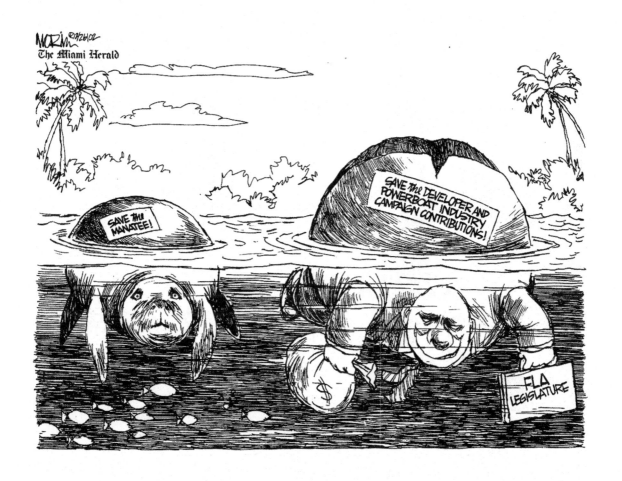

2/26/2002

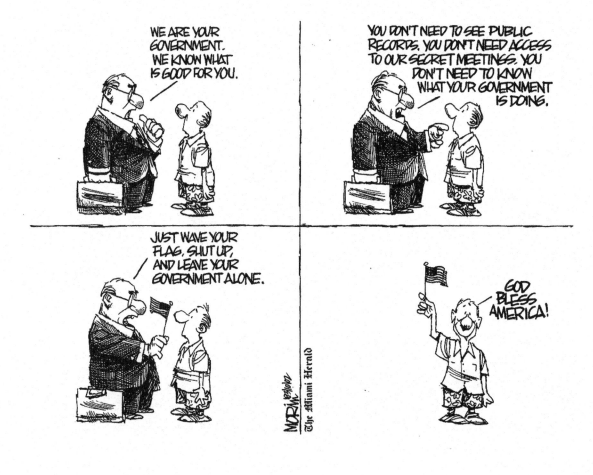

3/10/2002

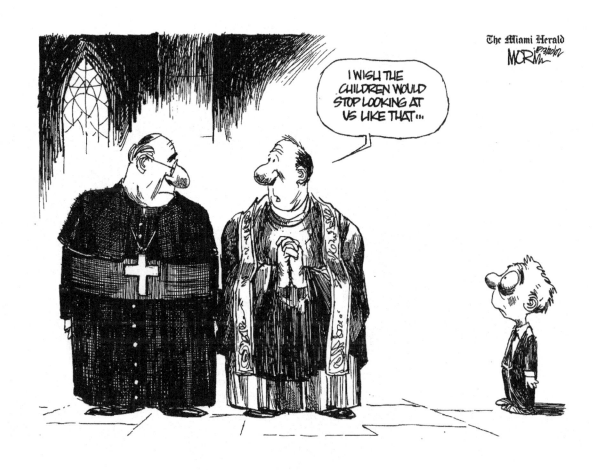

3/20/2002

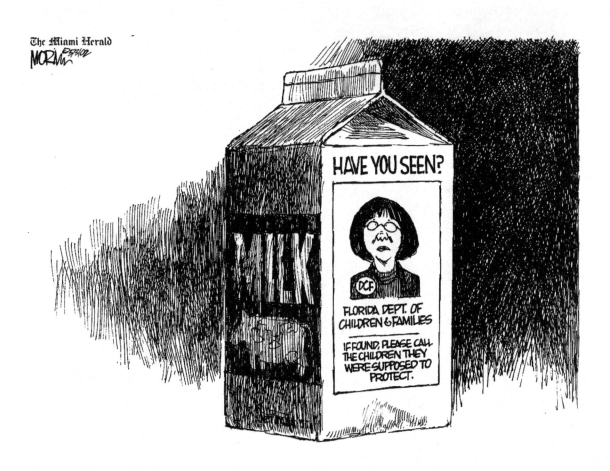

5/3/2002

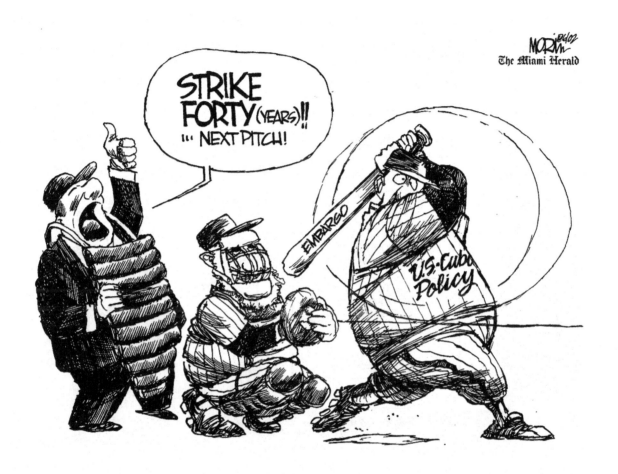

6/2002

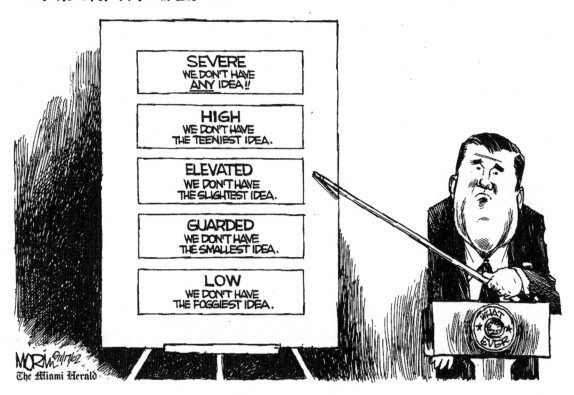

11/17/2002

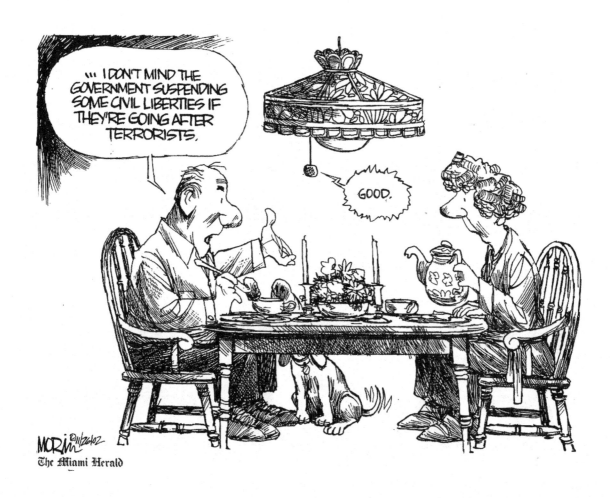

11/26/2002

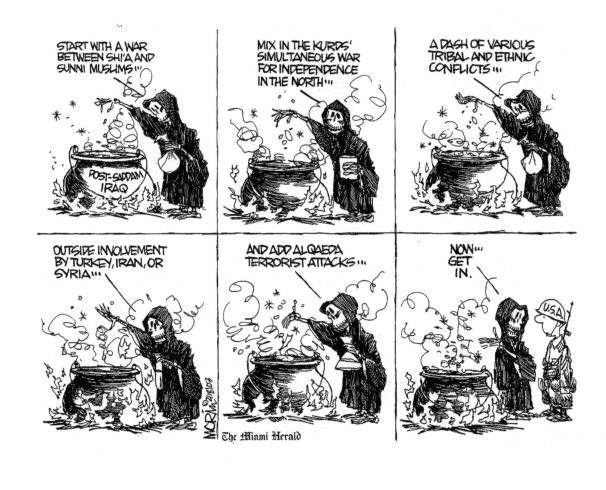

2/18/2003

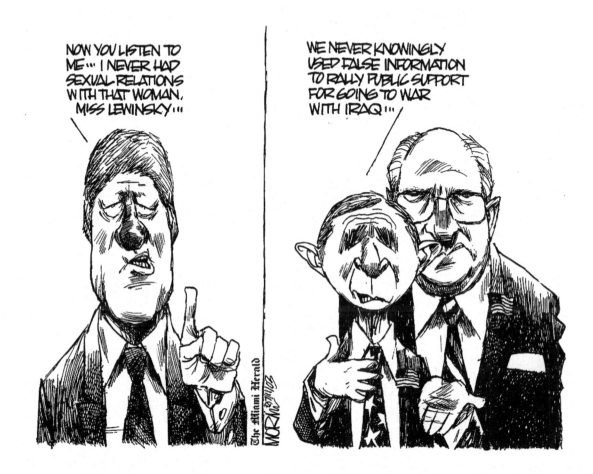

7/11/2003

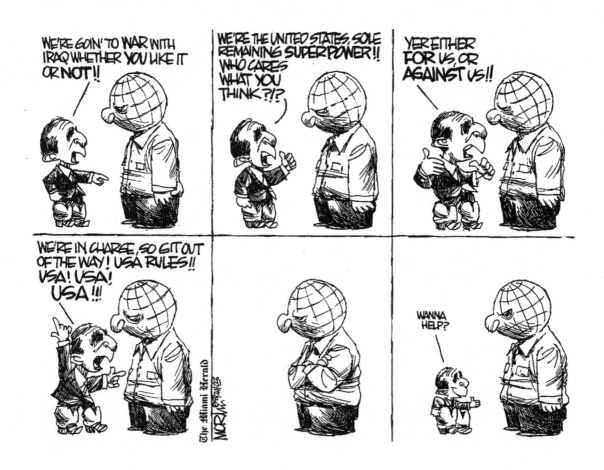

8/24/2003

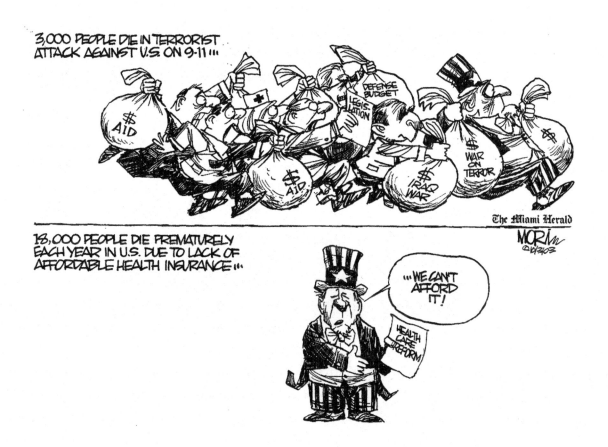

10/3/2003

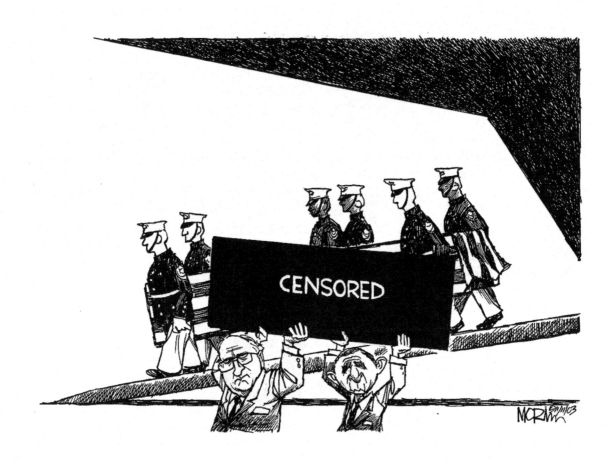

Military extends media ban to all installations for returning remains from Iraq war.

11/11/2003

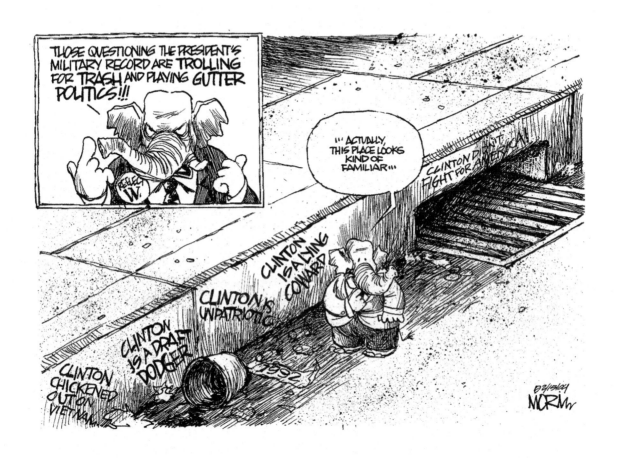

2/15/2004

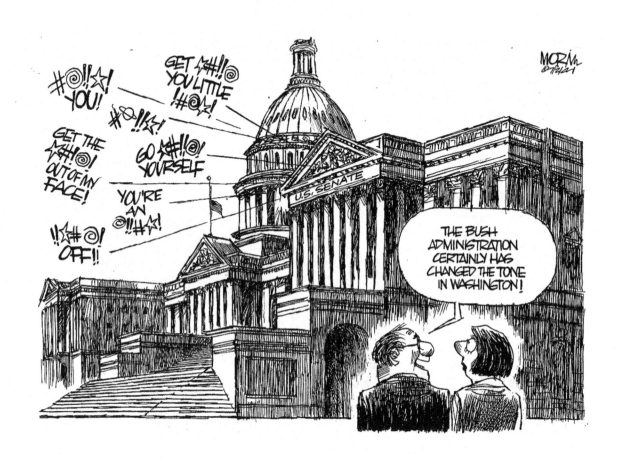

7/2/2004

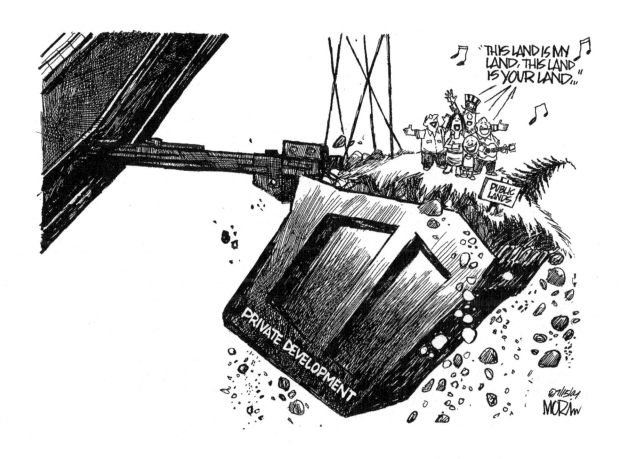

7/15/2004

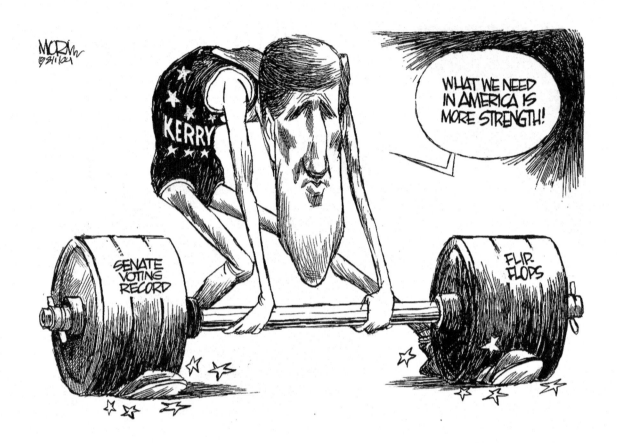

8/1/2004

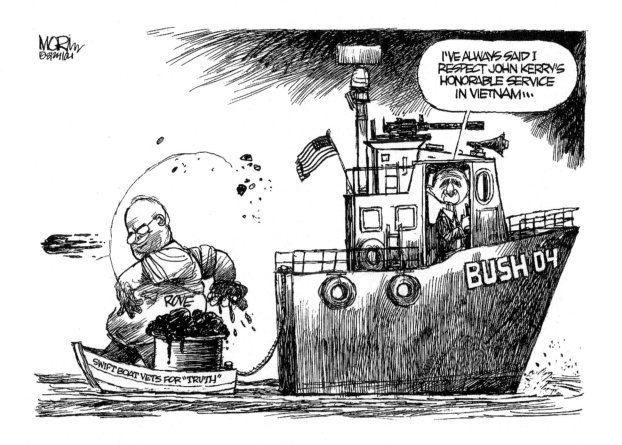

When you didn't fight in the Viet Nam war, smear the service of your opponent who did.
That is how low the 2004 presidential race could go.

8/21/2004

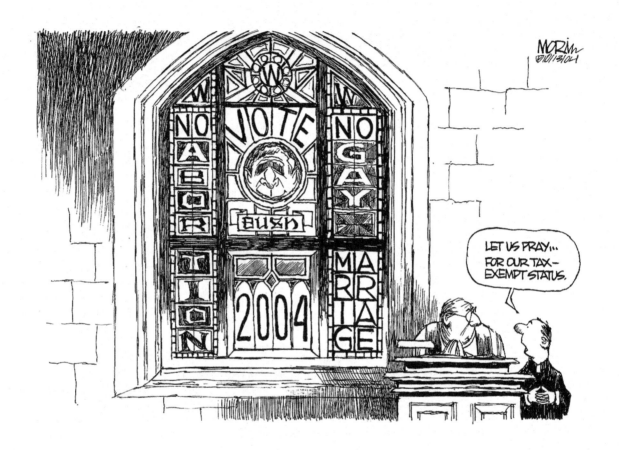

10/13/2004

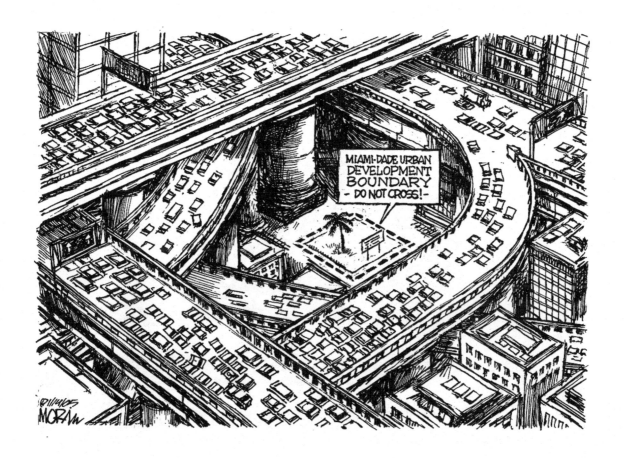

1/14/2005

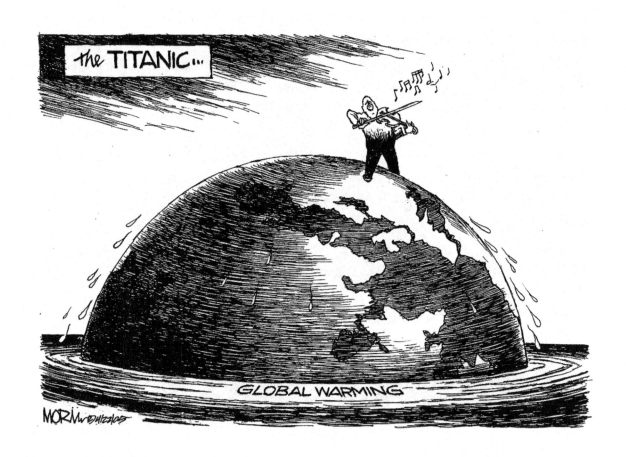

4/22/2005

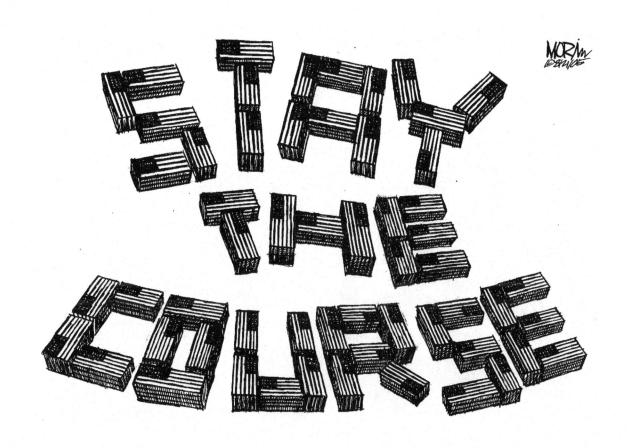

8/21/2005

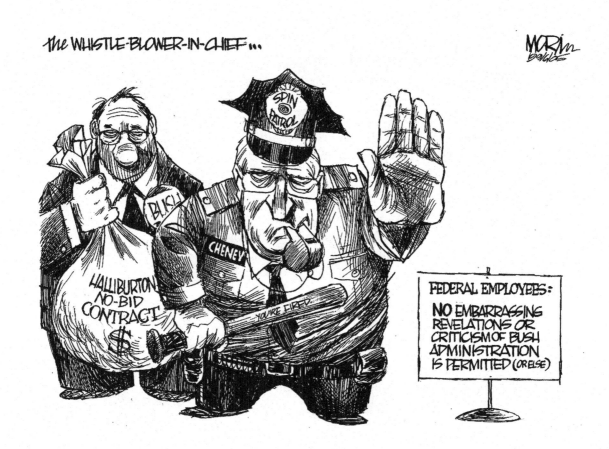

9/6/2005

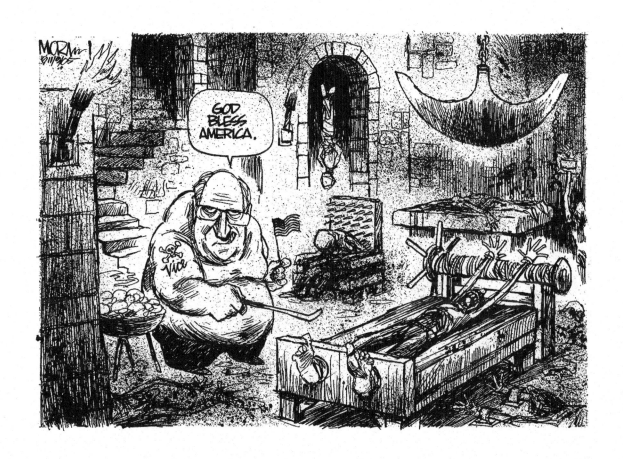

11/9/2005

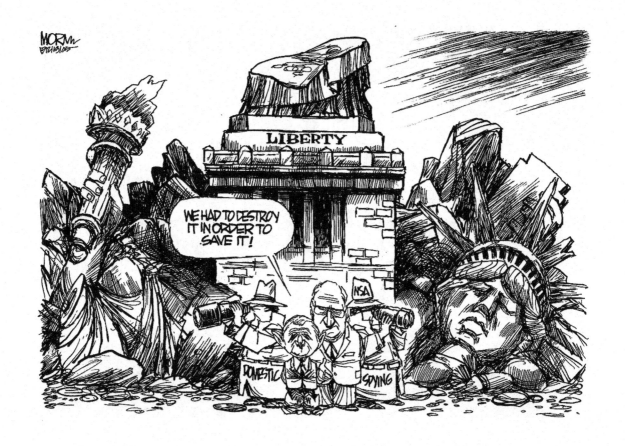

12/9/2005

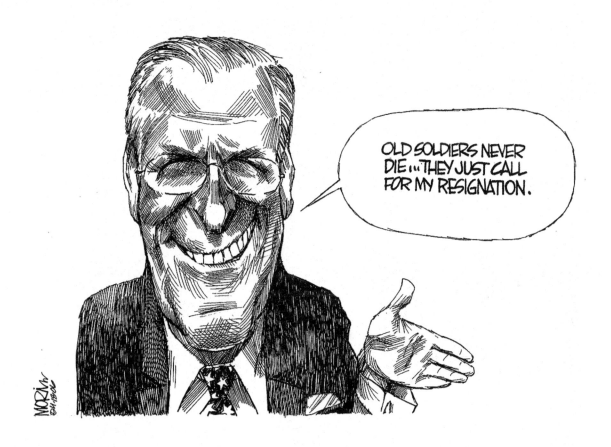

Secretary of Defense Donald Rumsfeld

4/18/2006

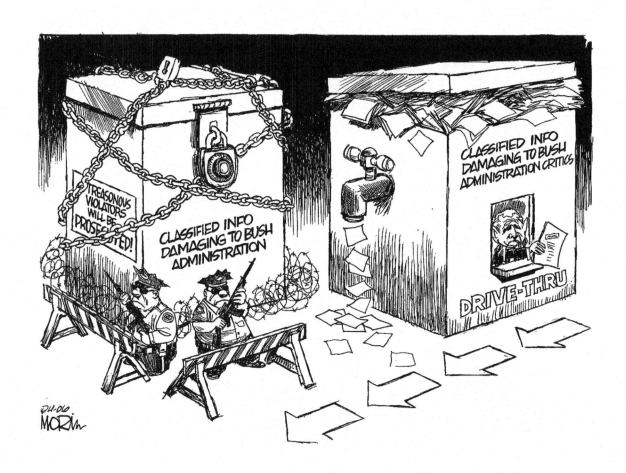

4/2006

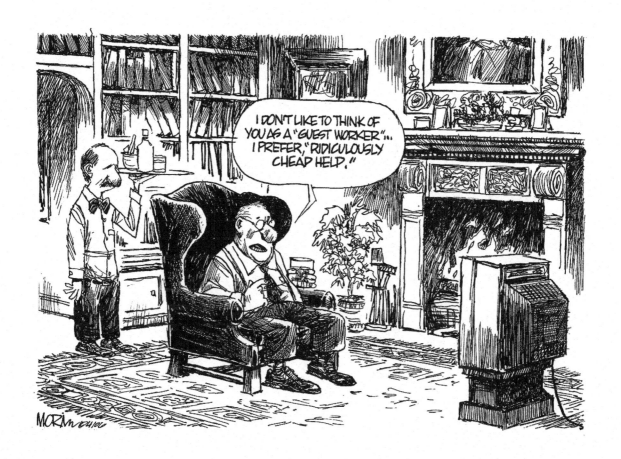

4/2006

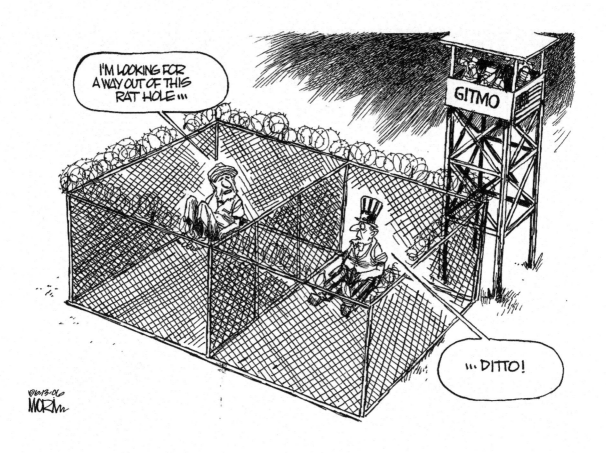

6/13/2006

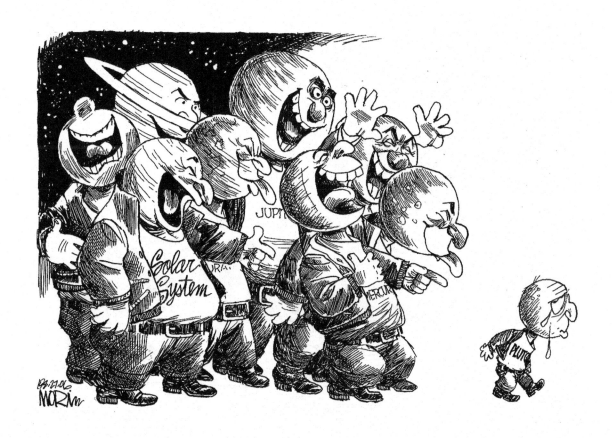

At a meeting of the International Astronomical Union (IAU) in Prague, Czech Republic, members voted Pluto out of the club of nine planets and relegated it to "dwarf planet" status.

8/27/2006

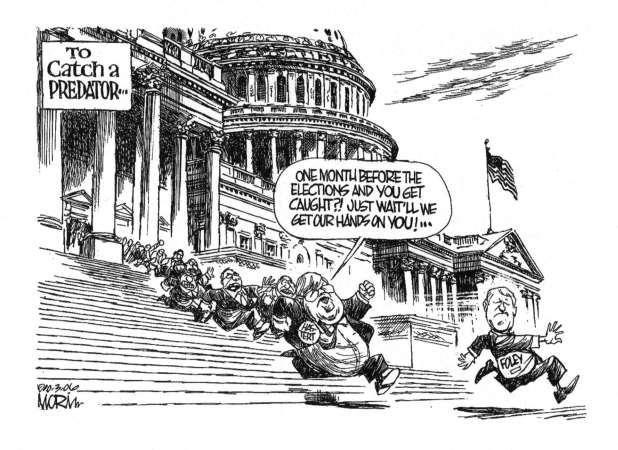

The Mark Foley scandal involving improper sexual conduct with teenage congressional pages broke in September 2006. It led to Foley's resignation on September 29 and is believed to have contributed to the Republican Party's loss of control of Congress in the November 7, election and the end of House Speaker Dennis Hastert's leadership role.

10/6/2006

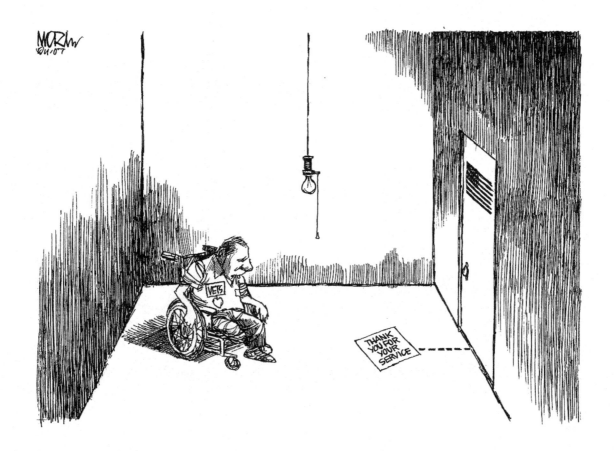

4/2007

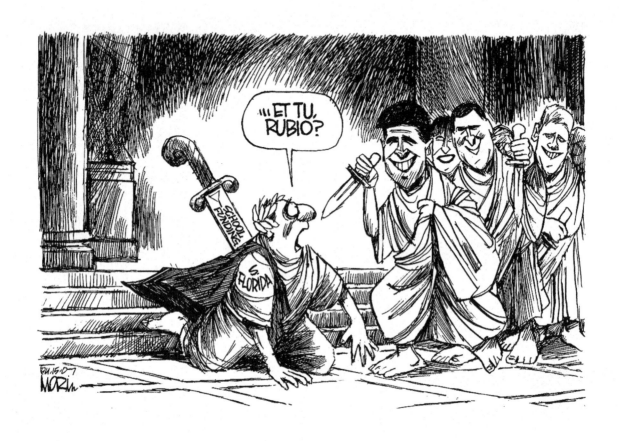

Nothing has changed. Marco Rubio is still out only for himself.

4/15/2007

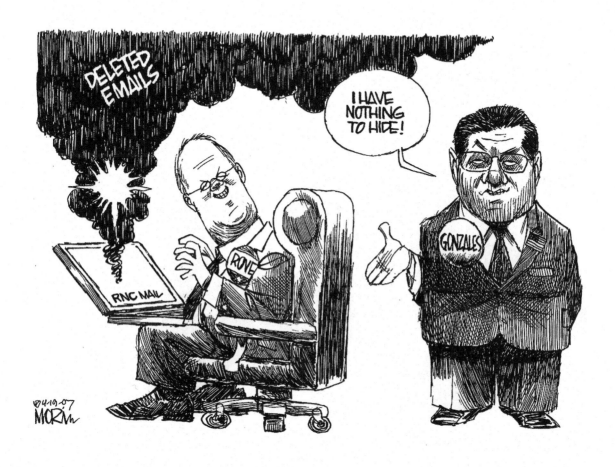

That's 22 million deleted emails. Now fast forward to 2016 and Hillary Clinton's email "scandal".

4/19/2007

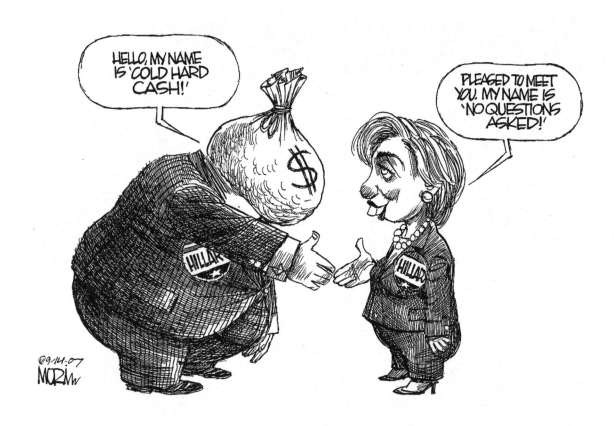

9/14/2007

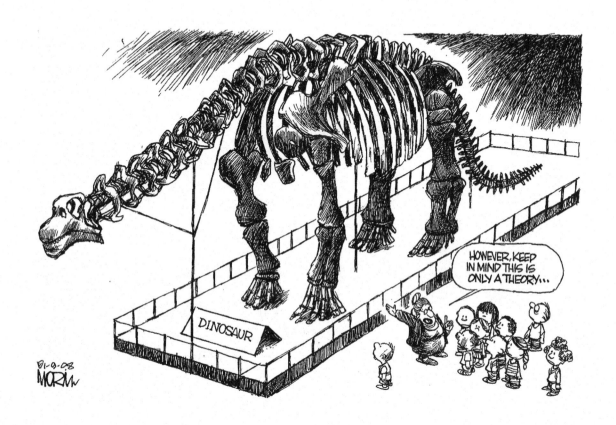

1/9/2008

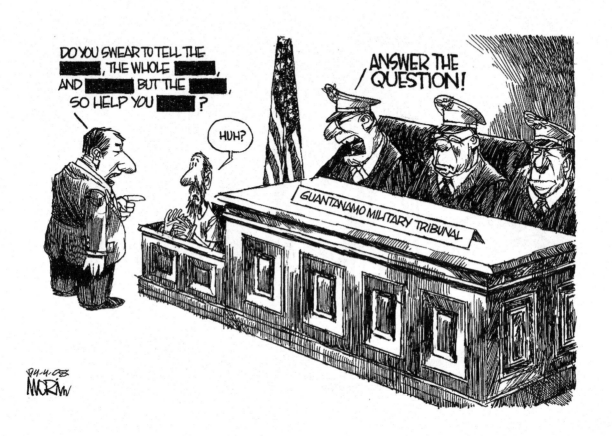

4/4/2008

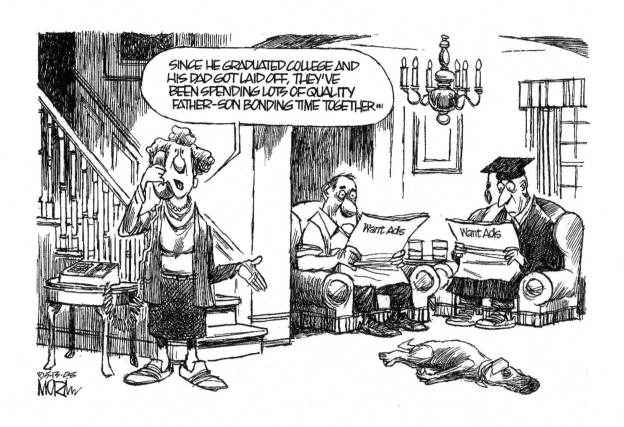

5/13/2008

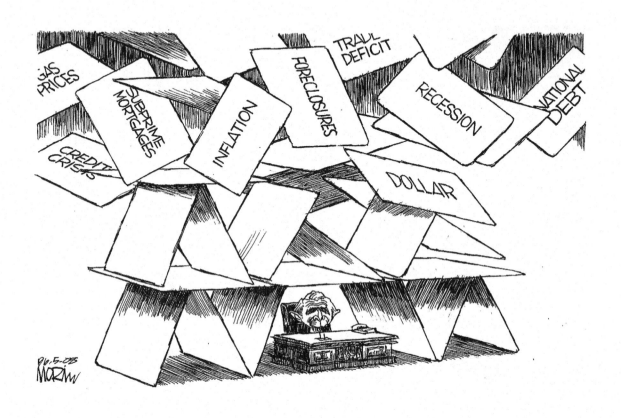

An $8 trillion housing bubble bursts leading to the Great Recession.

6/5/2008

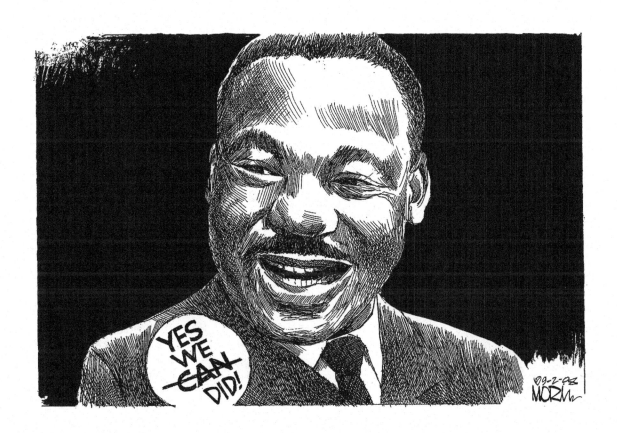

Barack Obama is nominated to represent the Democratic Party in the 2008 race.

9/2/2008

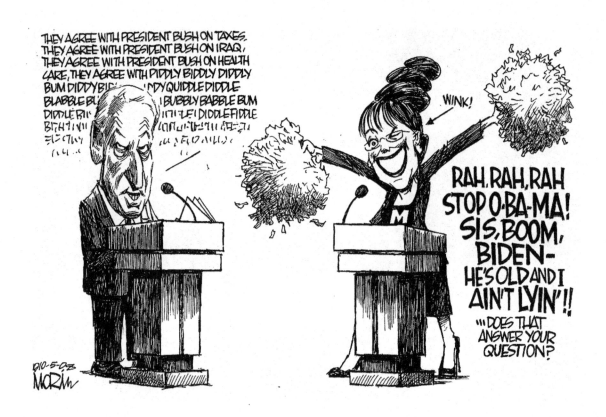

10/5/2008

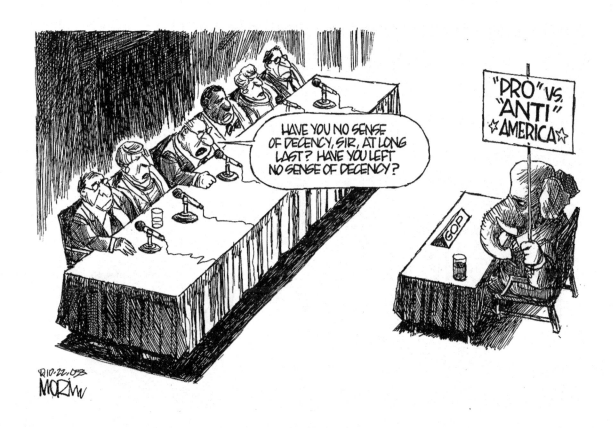

10/22/2008

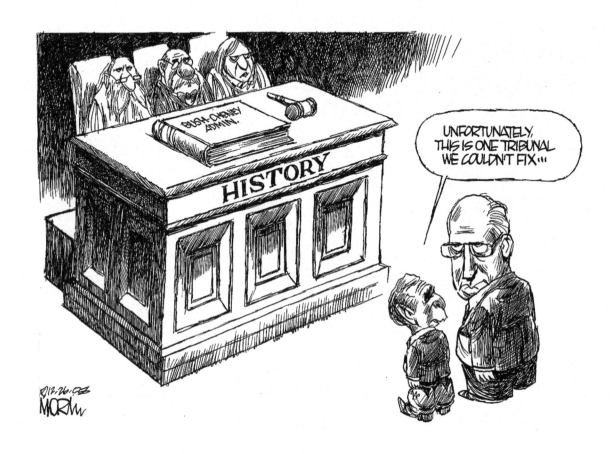

12/26/2008

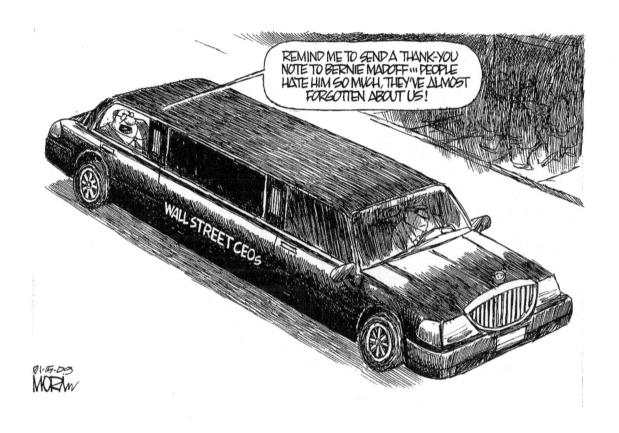

1/15/2009

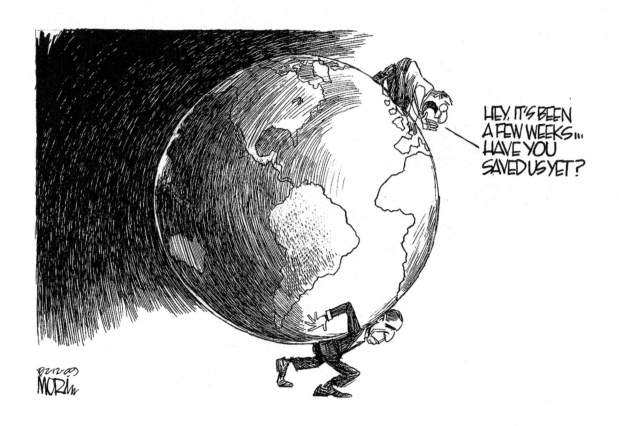

Obama wins the presidency. High expectations await his promises of hope and change.

2/12/2009

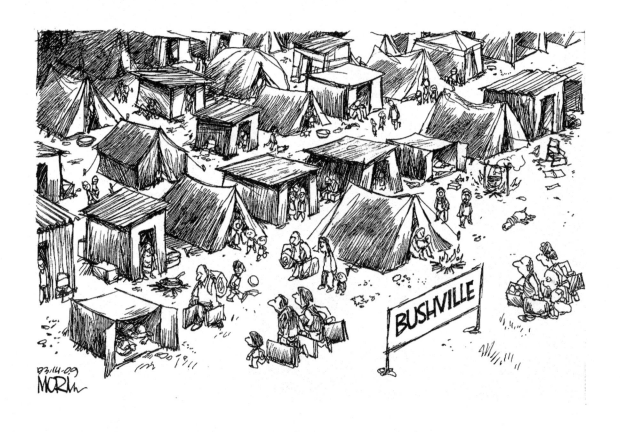

3/14/2009

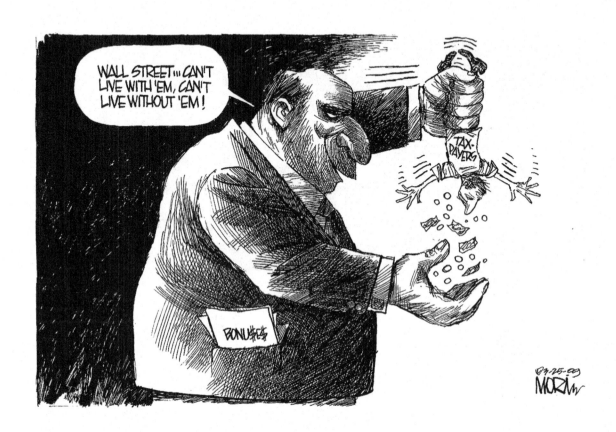

Taxpayers bail out Wall Street.

3/25/2009

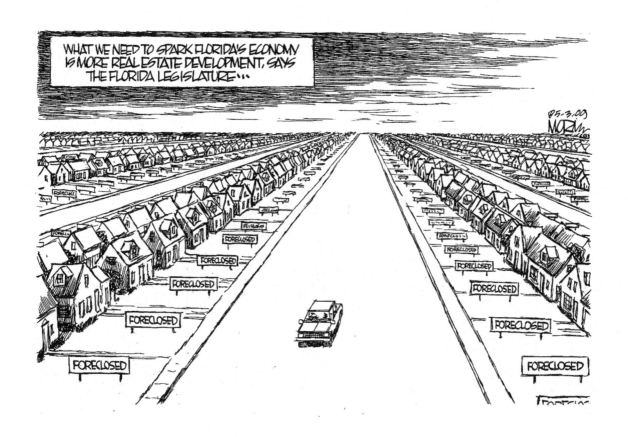

5/3/2009

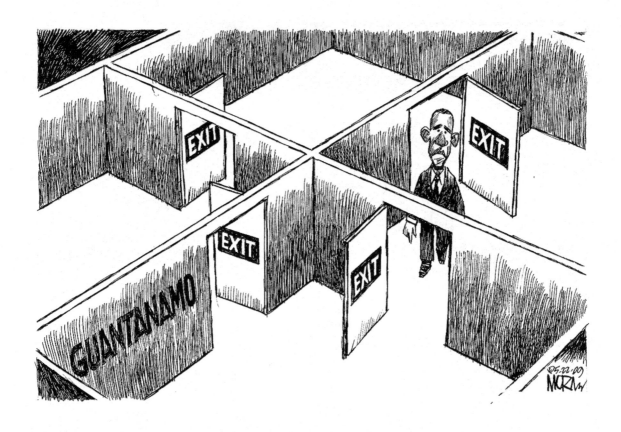

5/22/2009

CRIST-ME-LE-ON (n.) any of several political lizards capable of changing the color of their skin. Esp. common in southeastern United States.

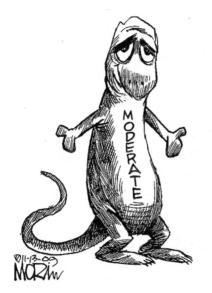
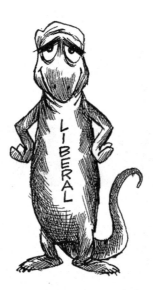
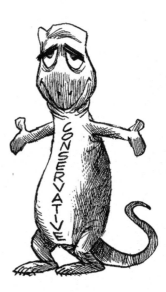

Former Florida Governor Charlie Crist.

11/13/2009

2010s

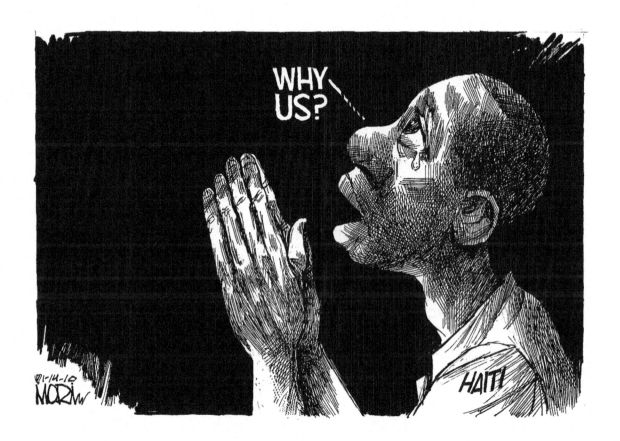

On 12 January 2010, Haiti suffered a catastrophic 7.0 magnitude earthquake that devastated Port-au-Prince and the Haitian people.

1/14/2010

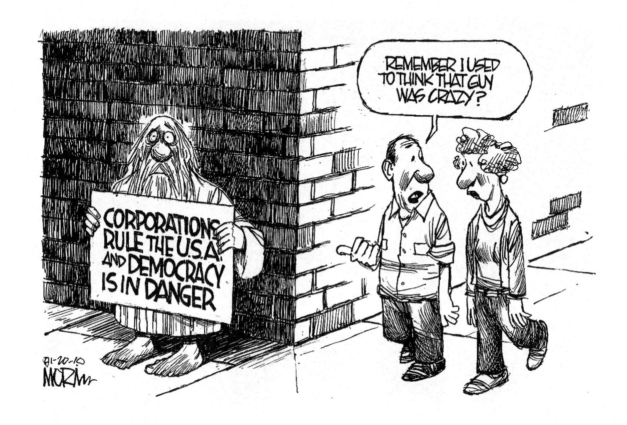

1/20/2010

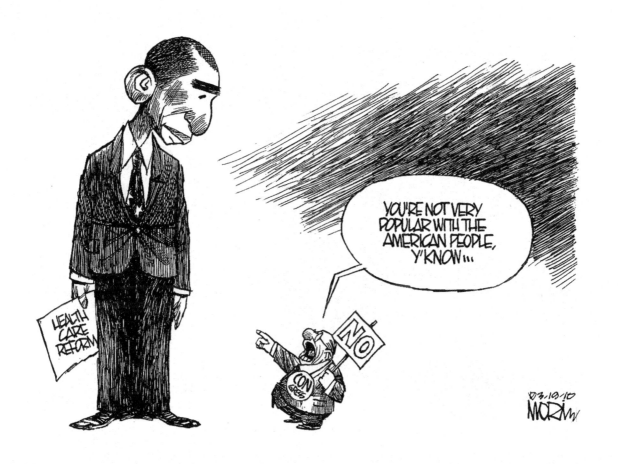

3/19/2010

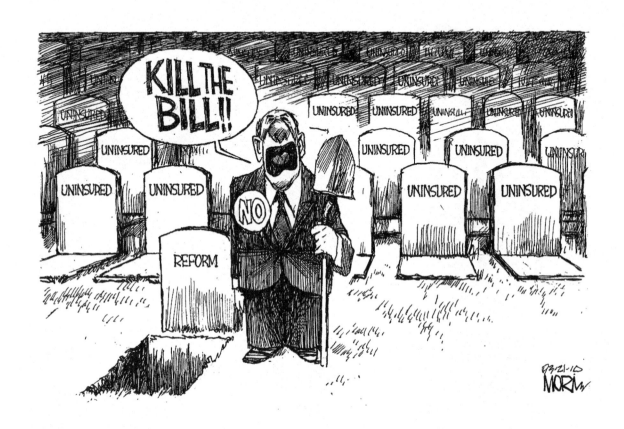

3/21/2010

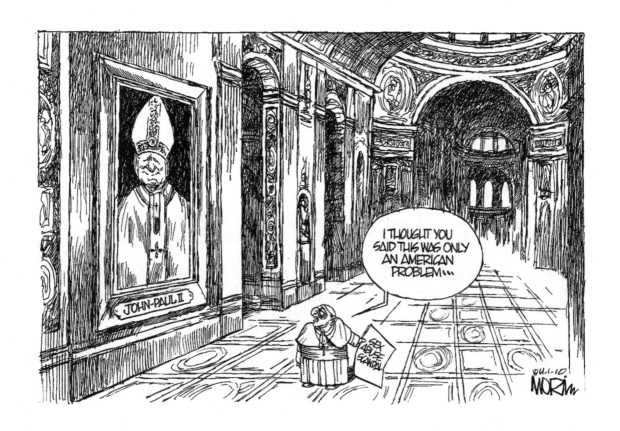

4/1/2010

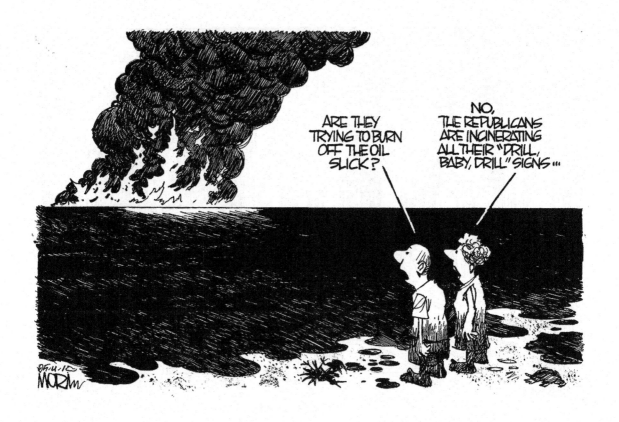

On April 20, 2010, BP's Deepwater Horizon oil rig exploded, killing 11 people and spilling oil and gas into the Gulf of Mexico. On July 15, the well was capped after an estimated 3.19 million barrels of oil fouled the waters and beachs of the Gulf.

5/4/2010

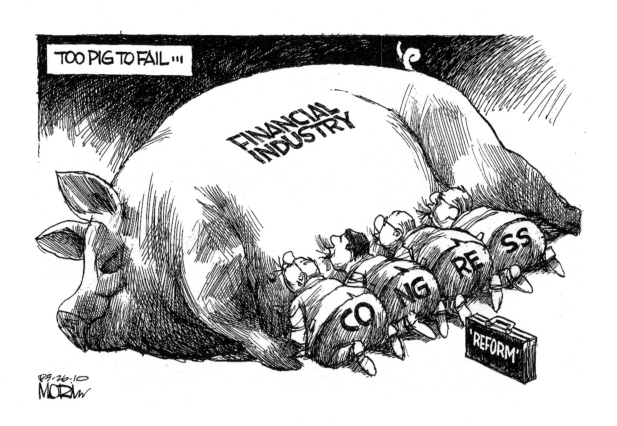

5/26/2010

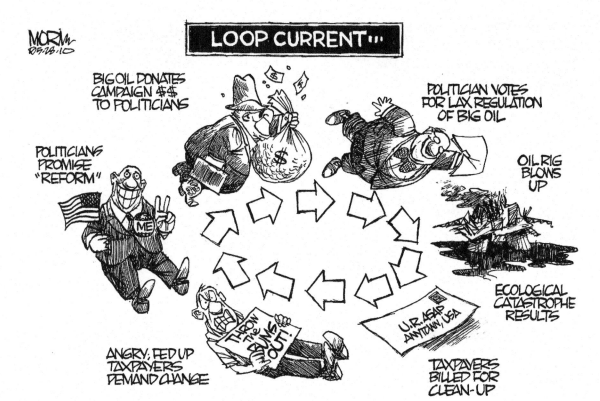

5/28/2010

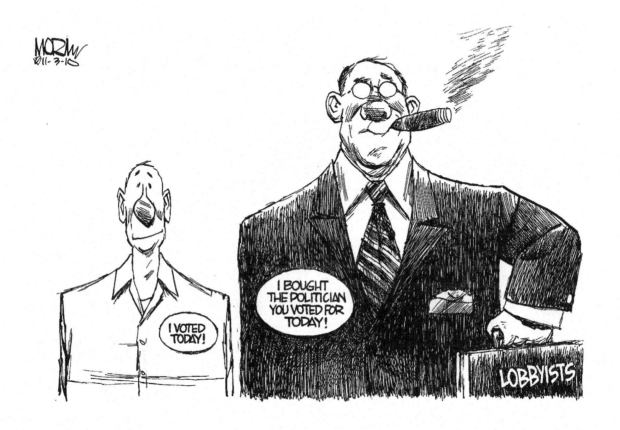

11/3/2010

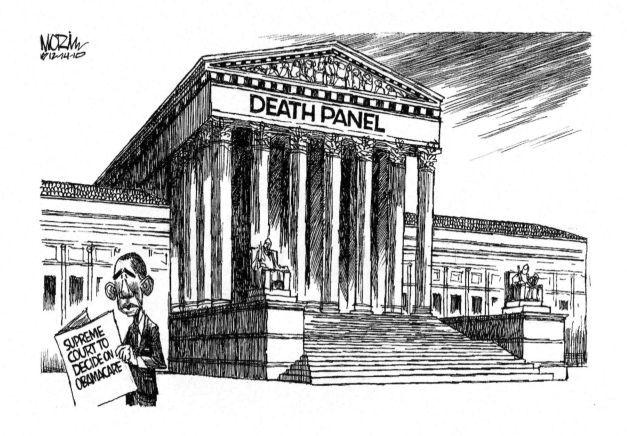

12/14/2010

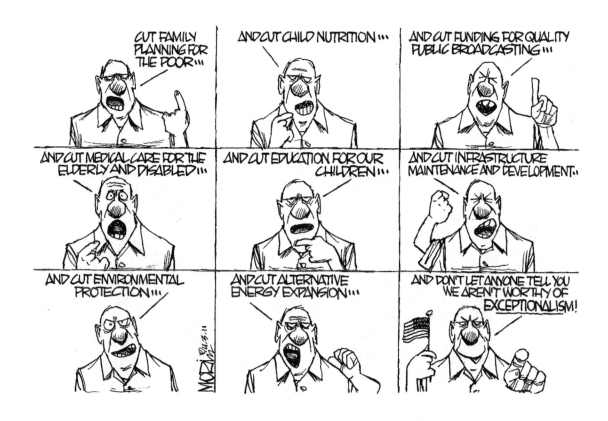

4/3/2011

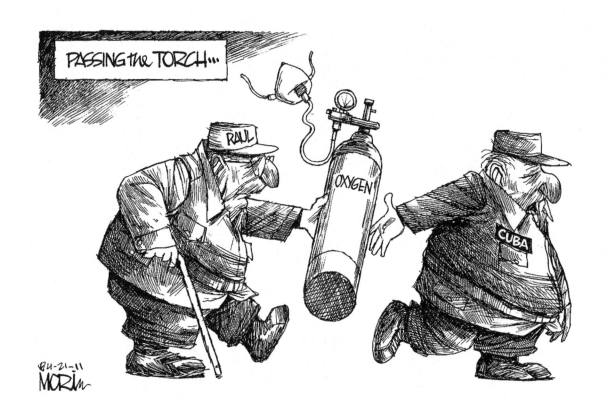

4/21/2011

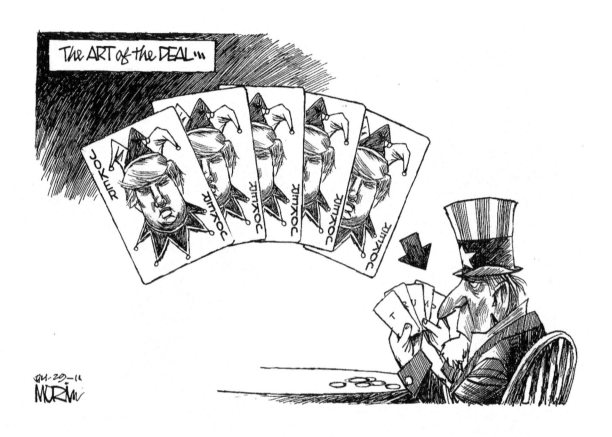

"The Art of the Deal" is a 1987 book by Donald Trump and journalist Tony Schwartz.
4/29/201

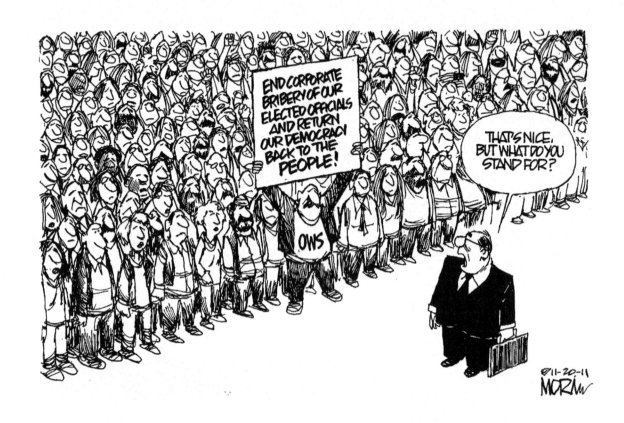

Occupy Wall Street is a citizens' movement against social and economic inequality.

11/20/2011

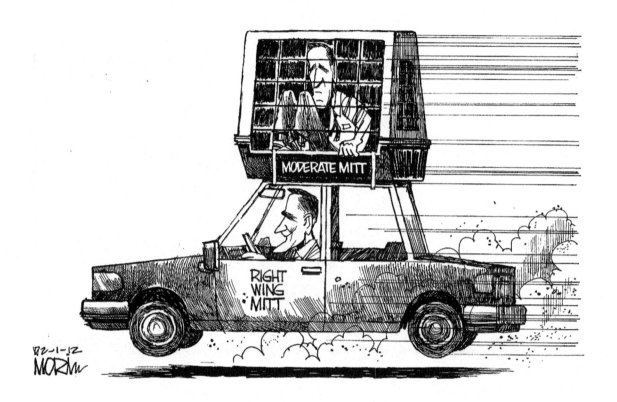

2/1/2012

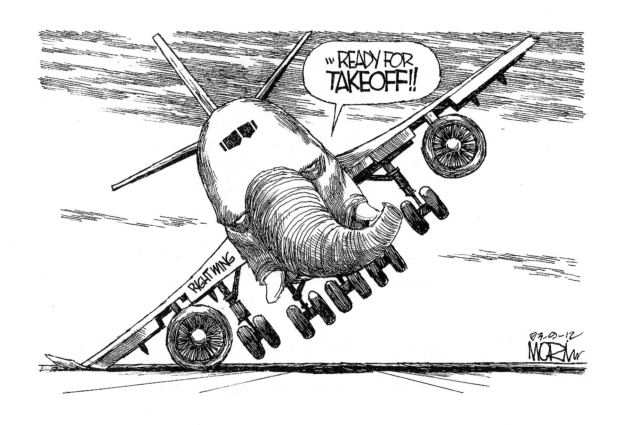

3/9/2012

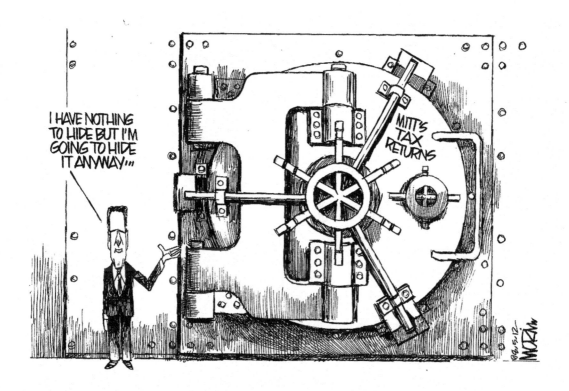

8/5/2012

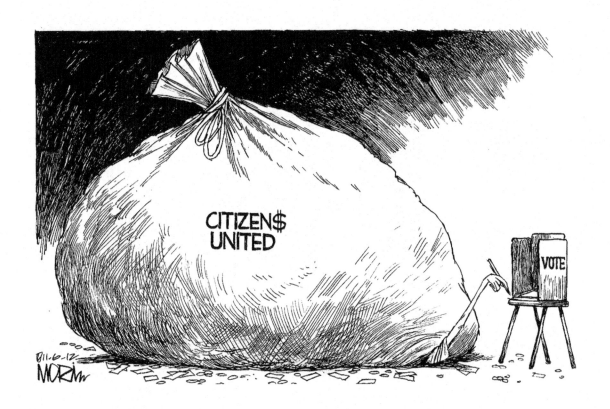

11/6/2012

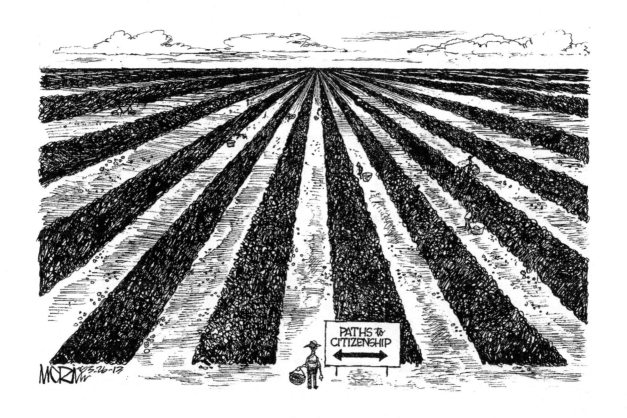

2/26/2013

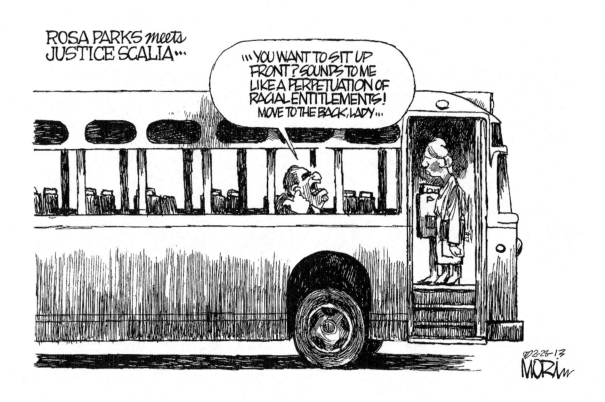

2/28/2013

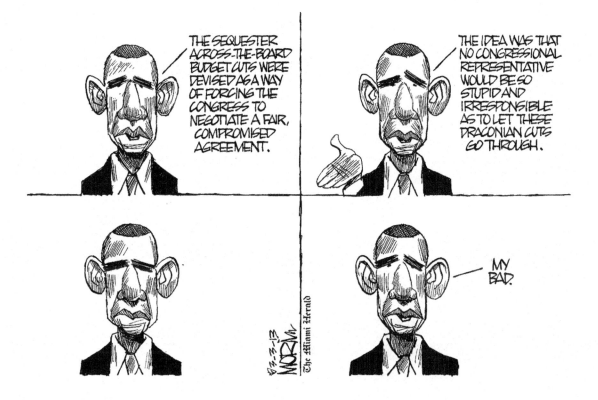

3/3/2013

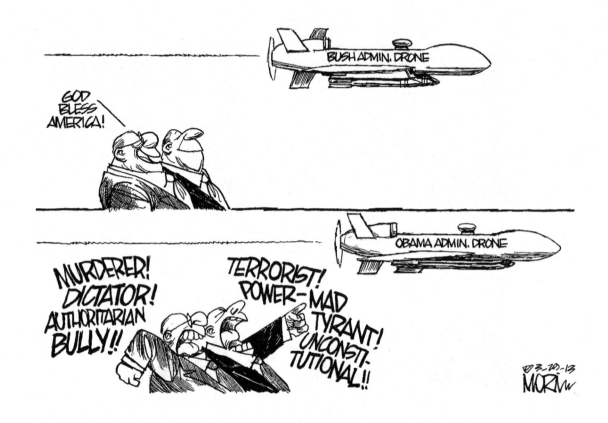

3/9/2013

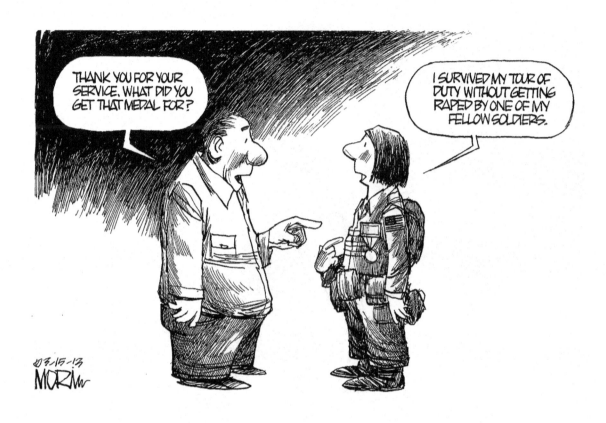

3/15/2013

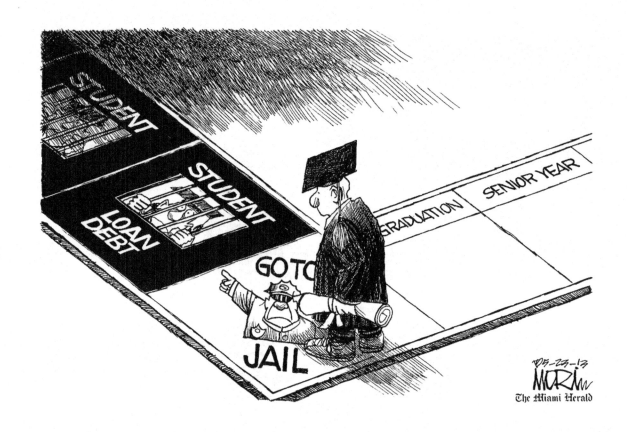

5/23/2013

WHAT IF···

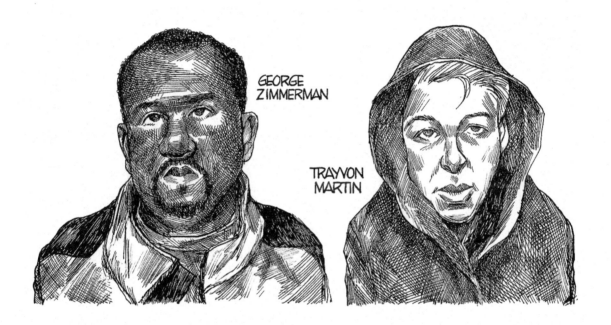

GEORGE ZIMMERMAN

TRAYVON MARTIN

George Zimmerman, an armed white Neighborhood Watch coordinator, fatally shot Trayvon Martin, an unarmed black teenager visiting relatives in a gated community. He was acquitted on self-defense grounds.

6/30/2013

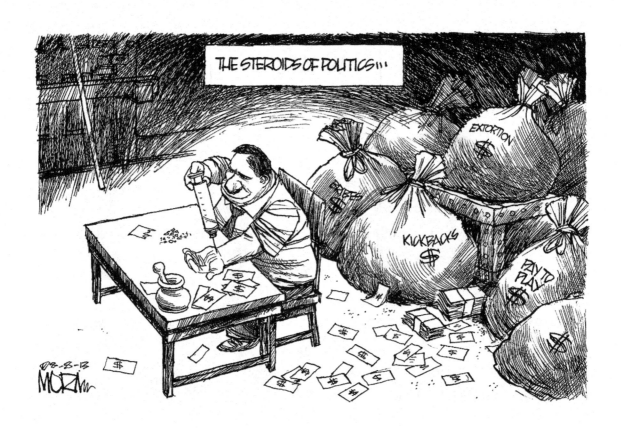

8/8/2013

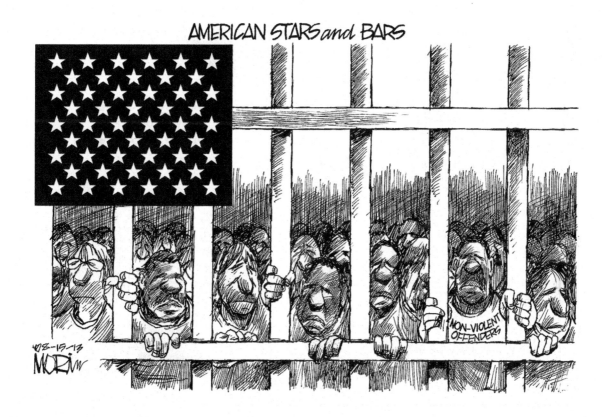

8/15/2013

PRESIDENTIAL EXECUTIVE ORDERS	
HARRY TRUMAN	907
DWIGHT EISENHOWER	484
JOHN F. KENNEDY	214
LYNDON JOHNSON	325
RICHARD NIXON	346
GERALD R. FORD	169
JIMMY CARTER	320
RONALD REAGAN	381
GEORGE H.W. BUSH	166
BILL CLINTON	364
GEORGE W. BUSH	291
BARACK OBAMA	168

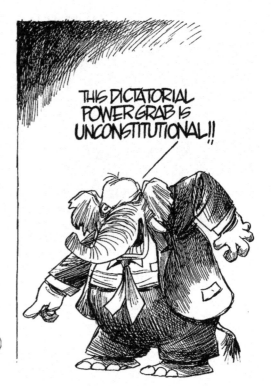

THIS DICTATORIAL POWER GRAB IS UNCONSTITUTIONAL!!

1/30/2014

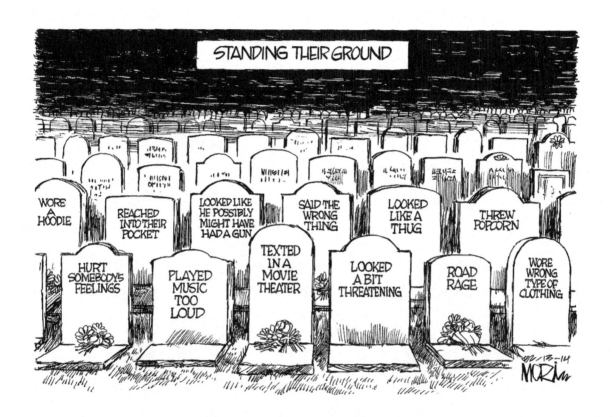

2/13/2014

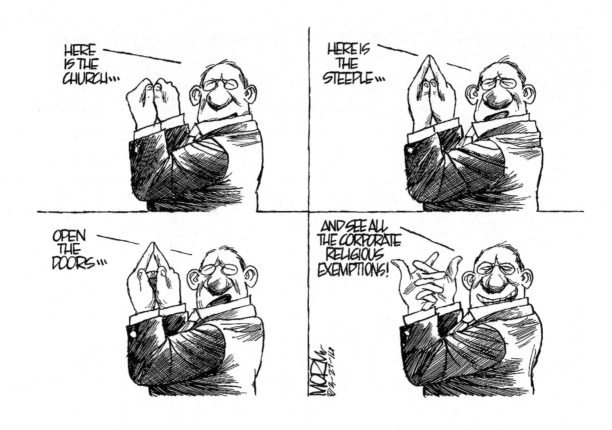

3/27/2014

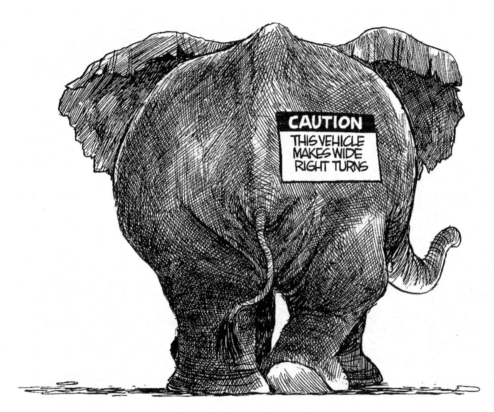

5/28/2014

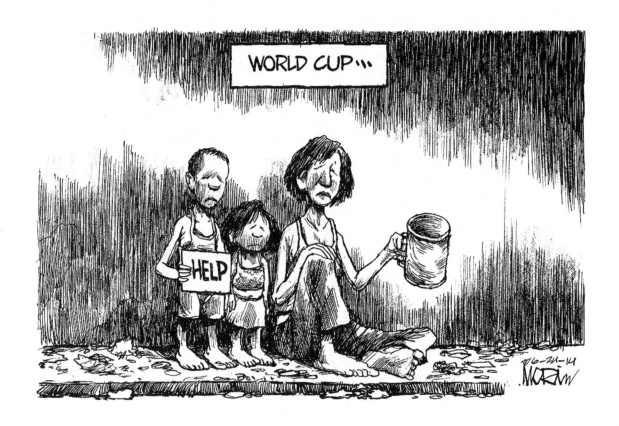

The costs of hosting international sports competitions in countries suffering from poverty becomes more controversial.

6/24/2014

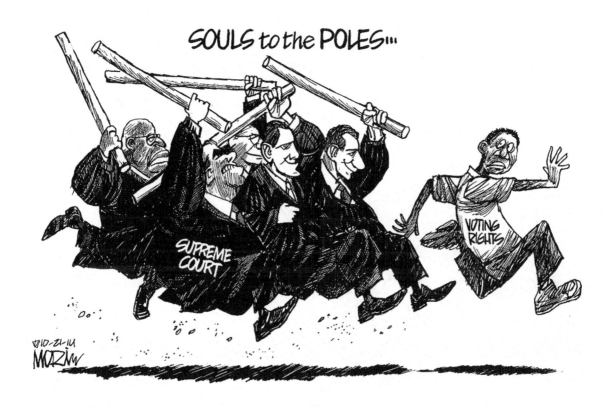

10/21/2014

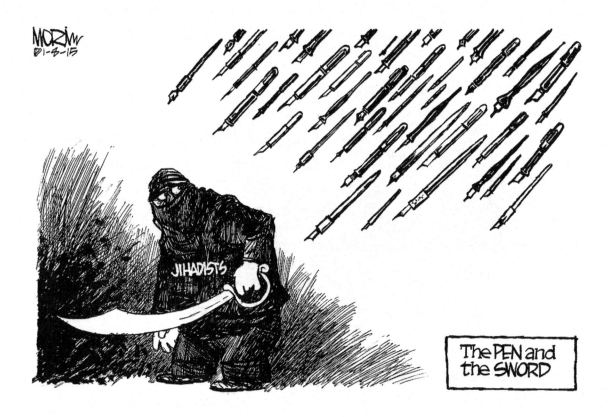

On January 7, 2015, Saïd and Chérif Kouachi, forced their way into the offices of the French satirical weekly newspaper Charlie Hebdo in Paris and killed 12 and injured 11 others.

1/8/2015

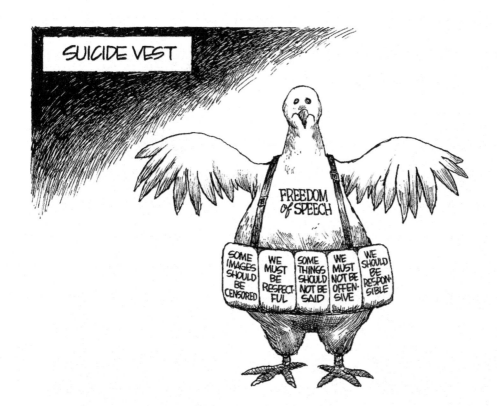

2/17/2015

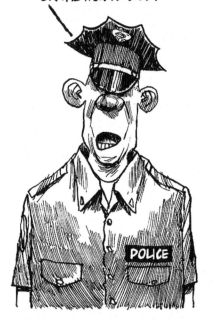

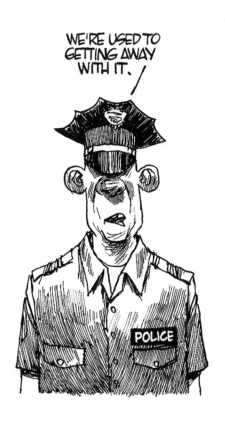

4/10/2015

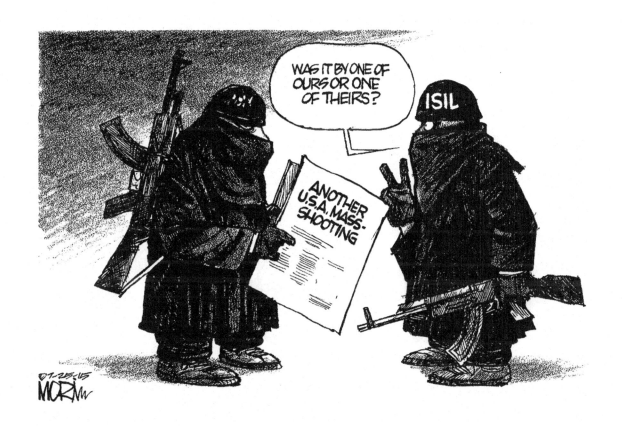

7/28/2015

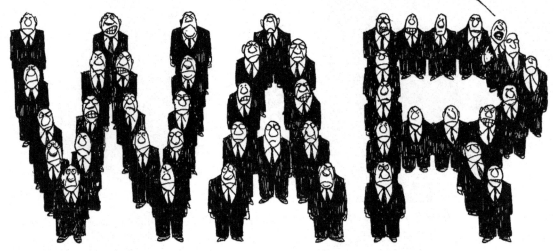

8/2/2015

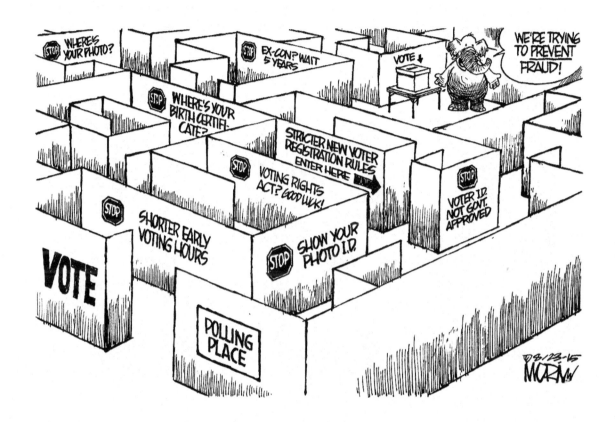

8/23/2015

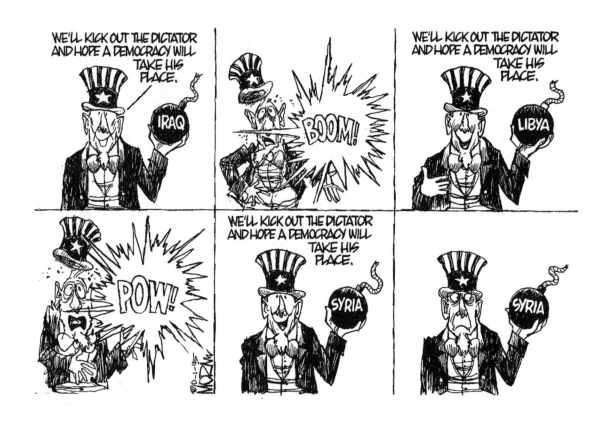

10/1/2015

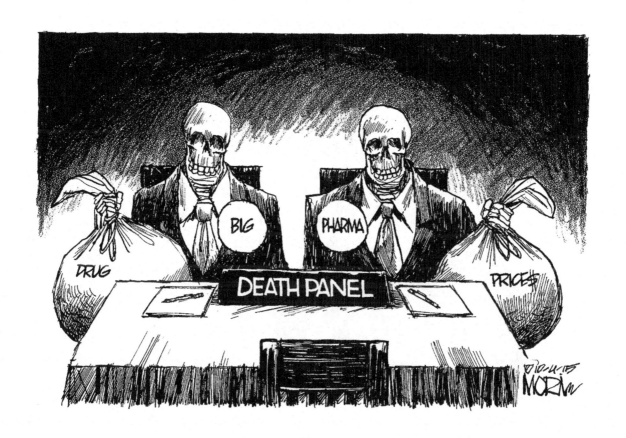

10/4/2015

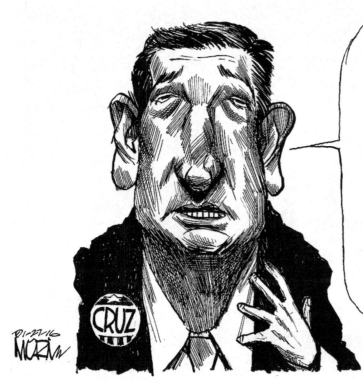

1/27/2016

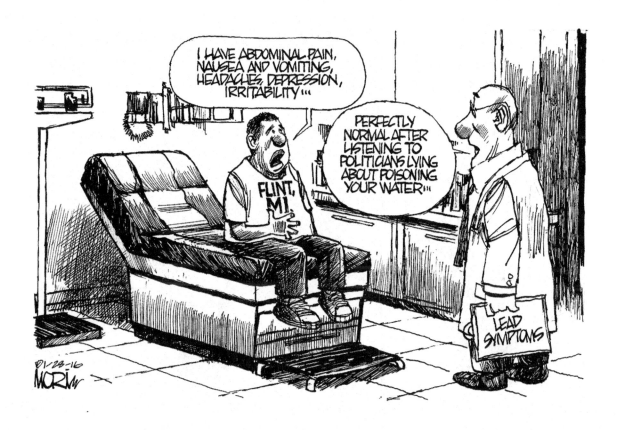

The Flint, Michigan water crisis began in April 2014 when the city changed its water supply from treated Detroit Water and Sewage Department water to Flint River water. Treated improperly, the water caused lead from aging pipes to leach into the water supply. In Janaury 2016, the governor declared a state of emergency.

1/28/2016

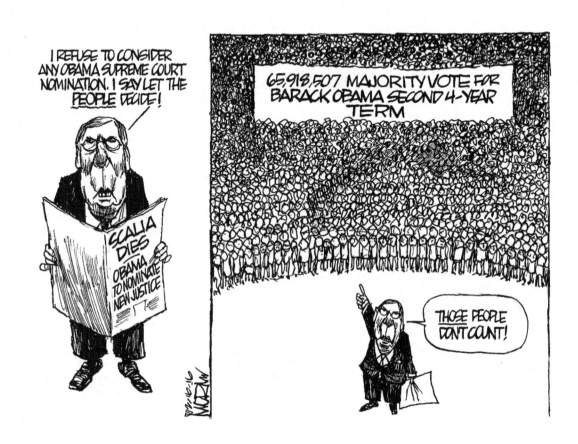

2/16/2016

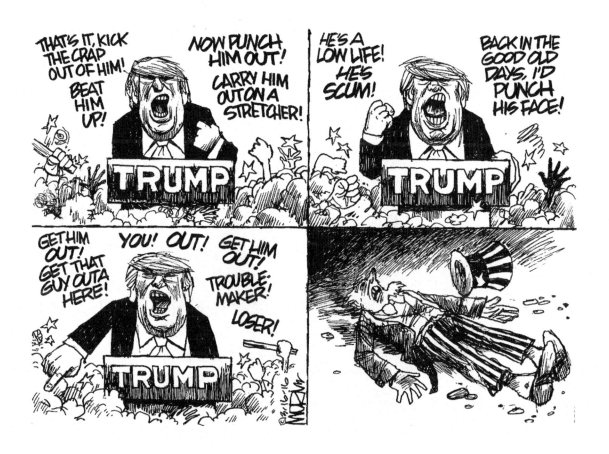

3/16/2016

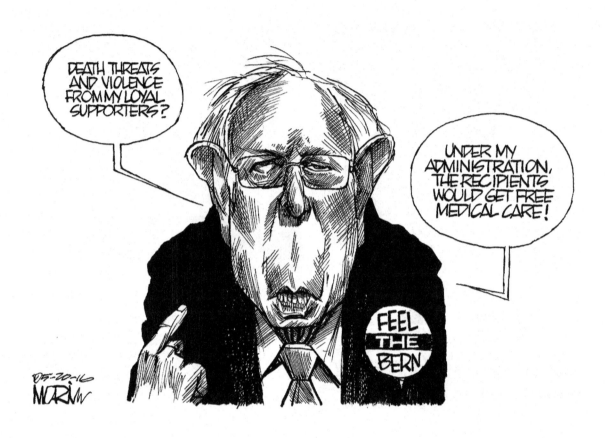

5/20/2016

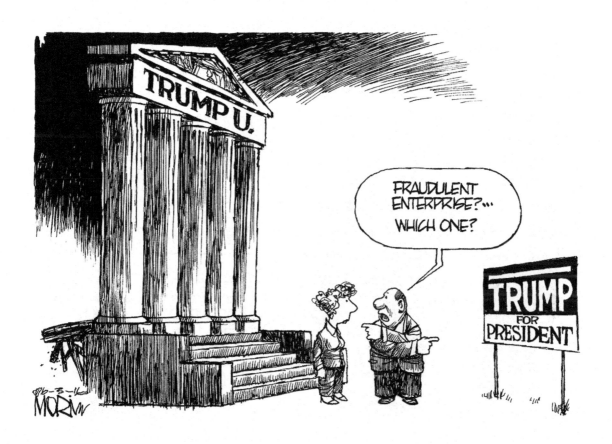

6/3/2016

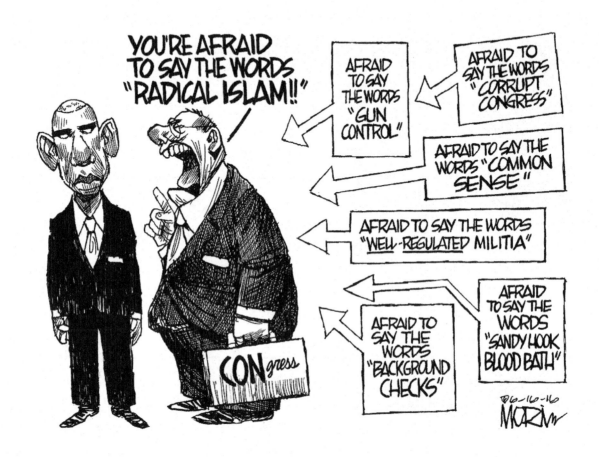

6/16/2016

BREXHALE

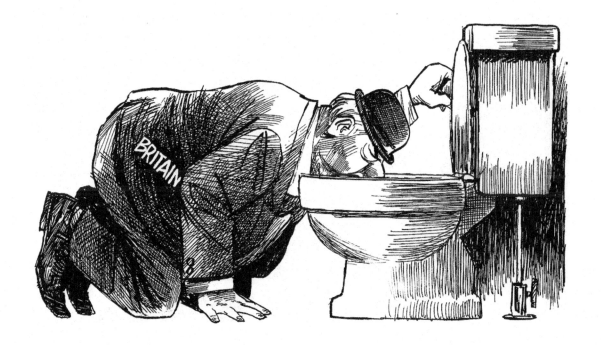

6/26/2016

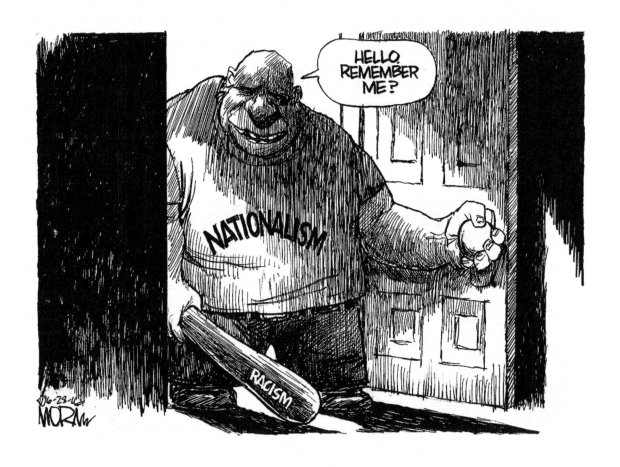

6/28/2016

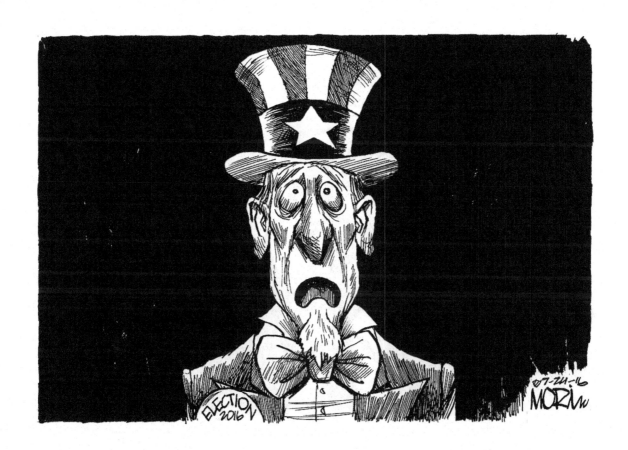

7/24/2016

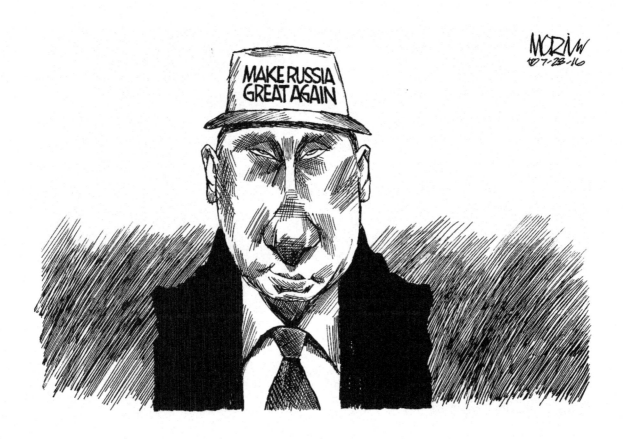

7/28/2016

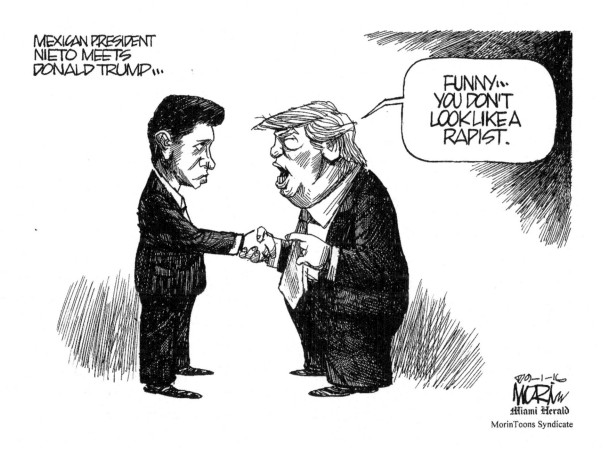

9/1/2016

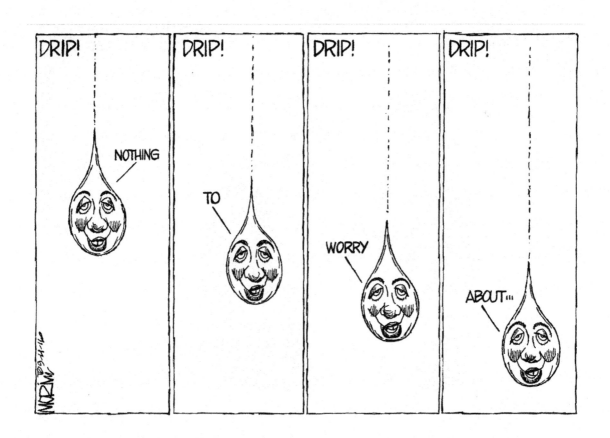

Hillary's e-Mail Scandal

9/4/2016

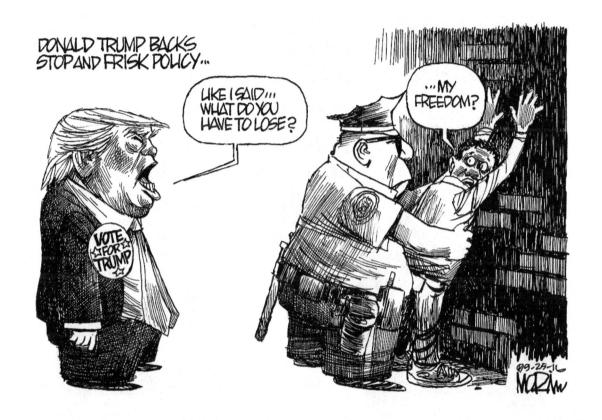

9/25/2016

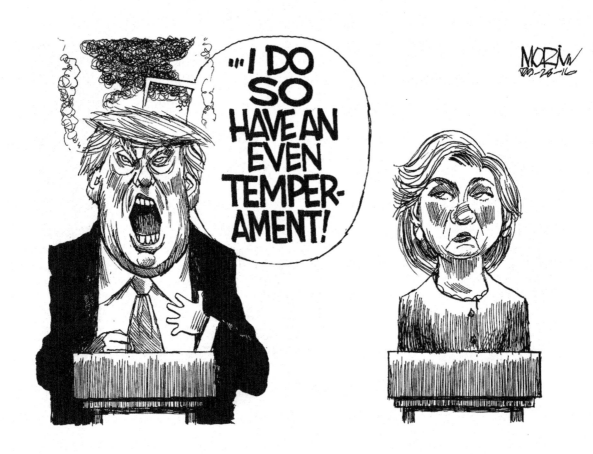

9/28/2016

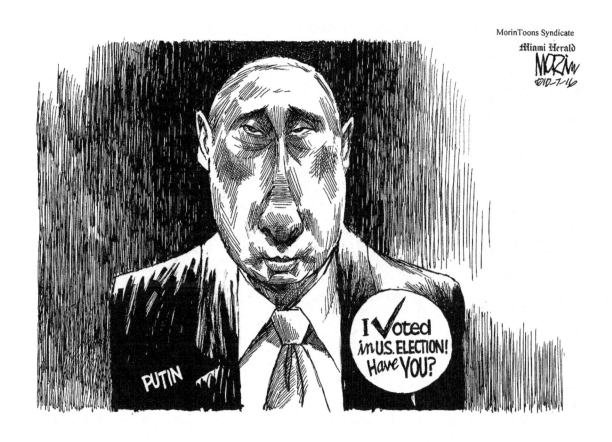

10/7/2016

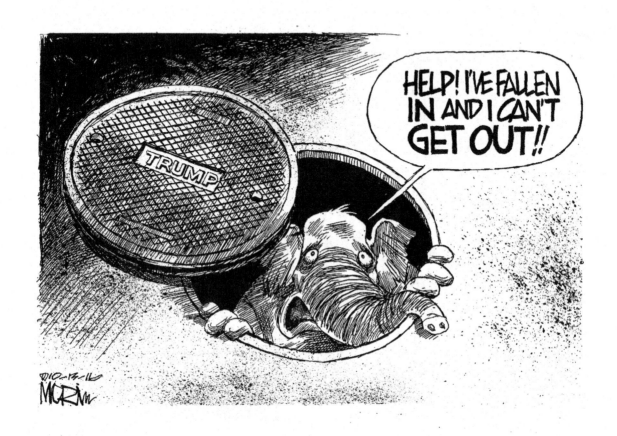

10/14/2016

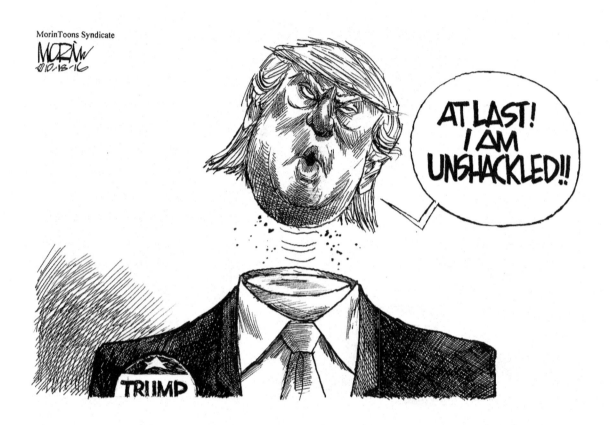

10/18/2016

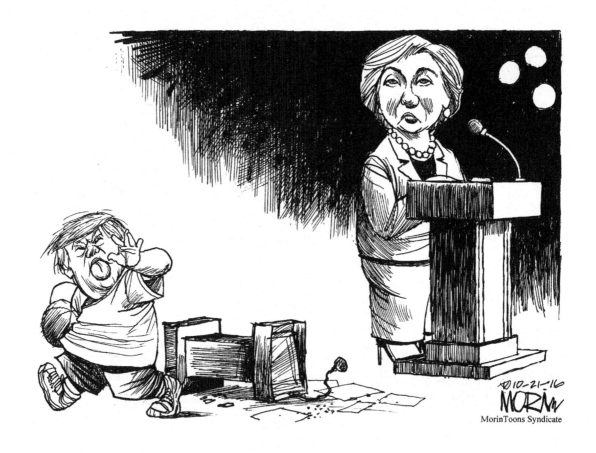

10/21/2016

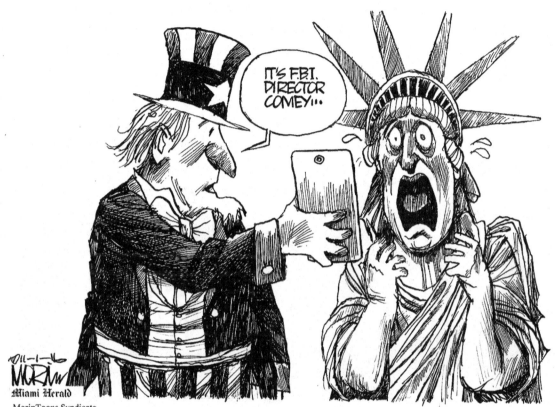

11/1/2016

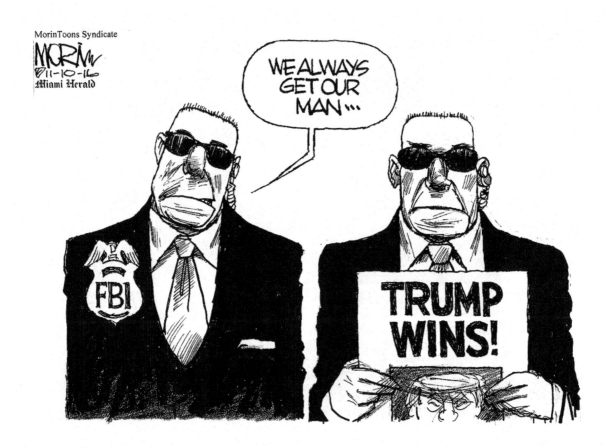

11/10/2016

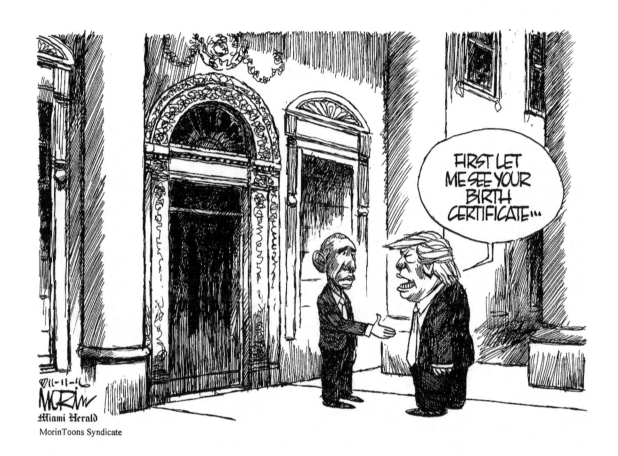

11/11/2016

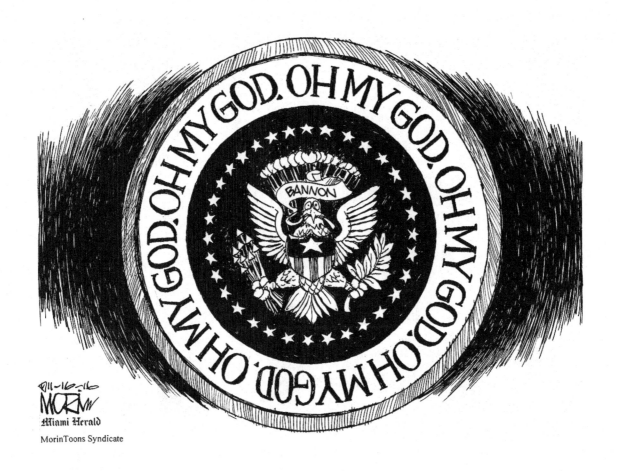

11/16/2016

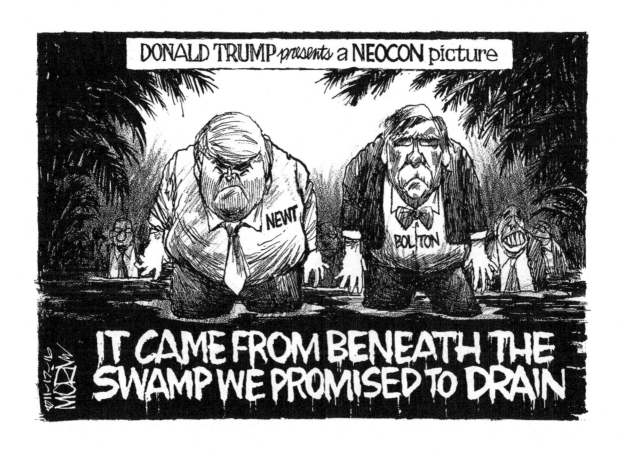

11/17/2016

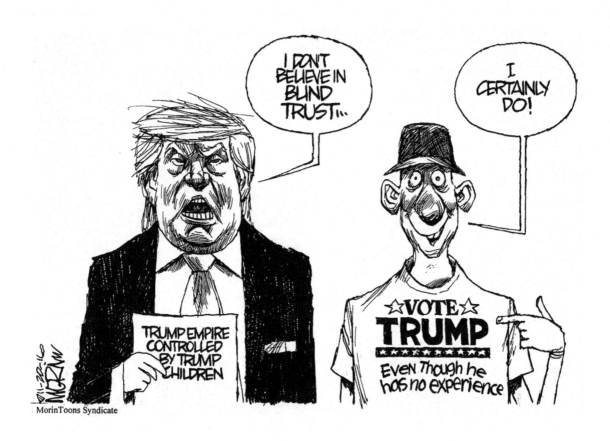

11/20/2016

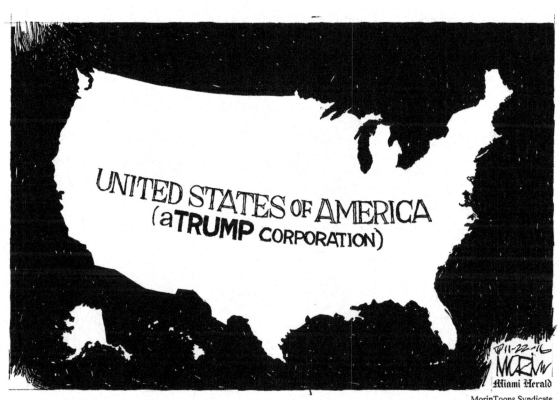

11/22/2016

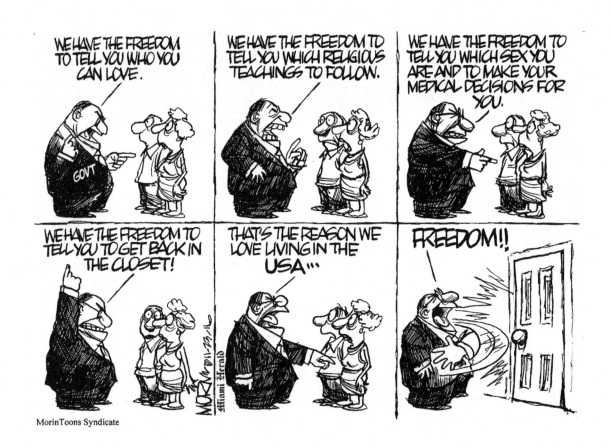

MorinToons Syndicate

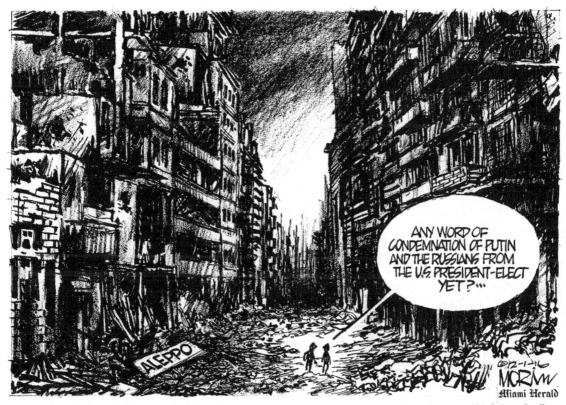

12/1/2016

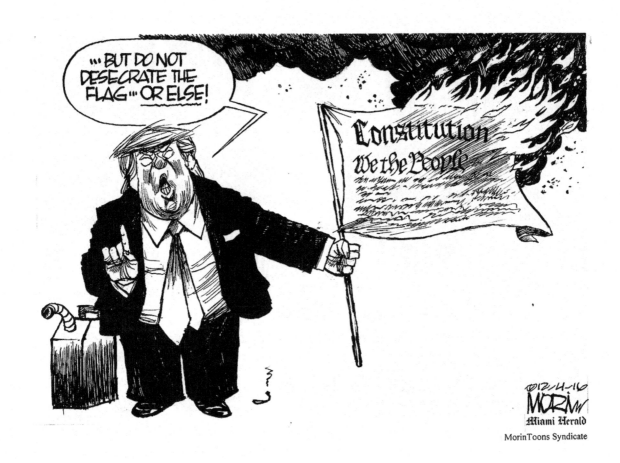

12/4/2016

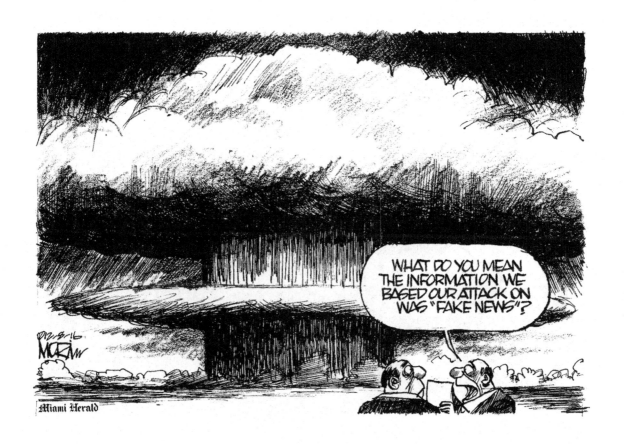

12/8/2016

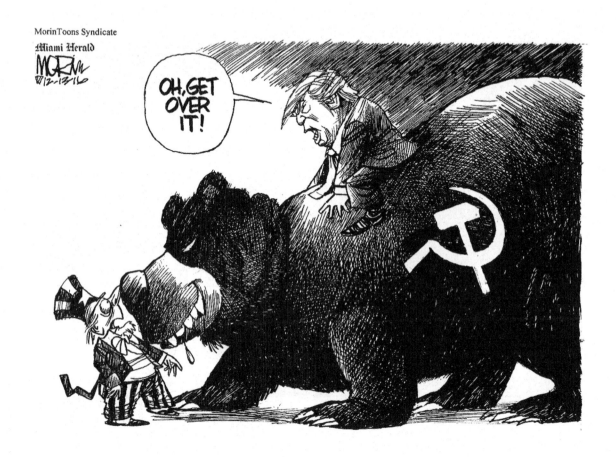

12/13/2016

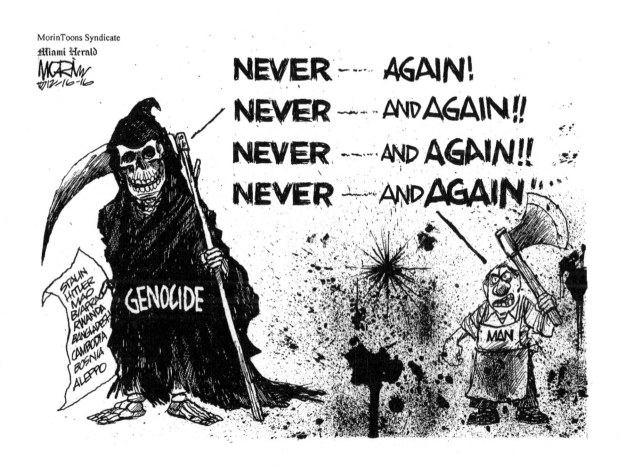

12/16/2016

CPSIA information can be obtained
at www.ICGtesting.com
Printed in the USA
BVOW09s2346260117
474396BV00004B/10/P